WORLD WAR II
AKRON

WORLD WAR II
AKRON

· · · · · · · · · · · · · · ★ · · · · · · · · · · · · · ·

TIM CARROLL

THE
History
PRESS

Published by The History Press
Charleston, SC
www.historypress.com

Copyright © 2019 by Tim Carroll
All rights reserved

First published 2019

Manufactured in the United States

ISBN 9781467139731

Library of Congress Control Number: 2018963531

Notice: The information in this book is true and complete to the best of our knowledge. It is offered without guarantee on the part of the author or The History Press. The author and The History Press disclaim all liability in connection with the use of this book.

CONTENTS

THE ROAD TO WAR

I n August 1937, the *Akron Beacon Journal* celebrated the American boy, noting that he could enjoy his youth in events like the All-American and International Soapbox Derby without worrying about the wars of Europe. The American boy's splendid isolation, and that of the nation, would not last. On December 14, 1941, the Soapbox Derby's major sponsor, General Motors, contacted *Beacon Journal* editor John S. Knight to inform him that the 1942 derby was canceled due to the shortage of rubber and other materials after the attack on Pearl Harbor.

Fast forward to 1962, when the *Beacon Journal* published a list of boys who competed in Akron's first derby in 1934 that the paper could not find, such as William Kottke, who participated at eleven and loved it so much he competed again in 1935, 1936, 1937 and one final time in 1938 at fifteen. The *Beacon Journal* didn't realize that it couldn't find him for a commemorative Soapbox Derby parade in 1962 because Lieutenant William Kottke died at twenty-two on January 23, 1945, when the B-29 bomber he was a flight engineer on was shot down on a raid over Tokyo. William's parents lost their only son, and he left behind his fiancée, Marilyn Rains.

In August 1940, fifteen-year-old Dan Climer was pictured in the *Beacon Journal* watching one of the last Soapbox Derbies before the war with his friends. Private First Class Dan Climer served in General Patton's Third Army and was killed in the Saar Valley in Germany at nineteen on December 18, 1944, during the German surprise attack that turned into the Battle of the Bulge. The American boy was built for peace, but he went to war.

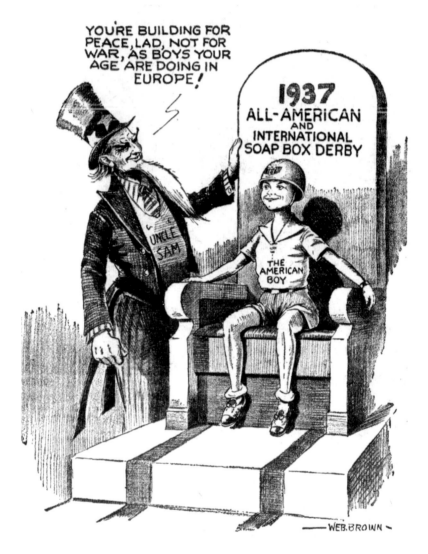

The American boy was building for peace in 1937. *Reprinted with permission of the* Akron Beacon Journal *and Ohio.com.*

But the road to war did not run smoothly, and the nation travelled slowly and reluctantly toward conflict. President Roosevelt visited Akron on October 11, 1940, and was greeted by a crowd of forty thousand at Akron's Union Station. The Republican and Democratic platforms of 1940 were essentially the same, with both candidates promising to keep America out of war. Many Akronites felt the same.

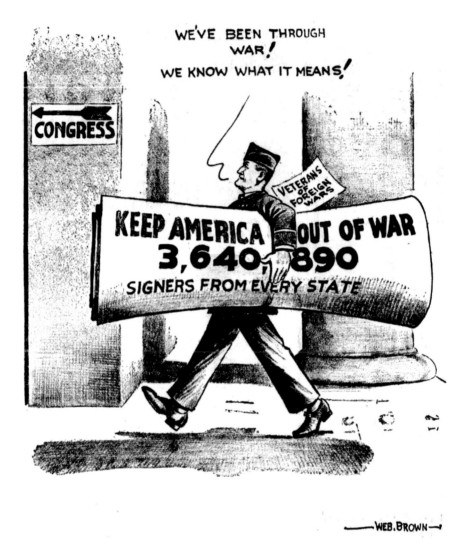

Capitol Hill gets a powerful petition. *Reprinted with permission of the* Akron Beacon Journal *and Ohio.com.*

One such person was John M. Carroll, my grandfather, who was drafted on March 1, 1941. The peacetime draft was started when Nazi Germany conquered France as Americans became concerned about the growing Nazi threat. The peacetime draft had little to do with Japan. The Central Armory in Cleveland, which many Summit County and Northeast Ohio draftees were sent to in 1941, was located at Lakeside Avenue and East

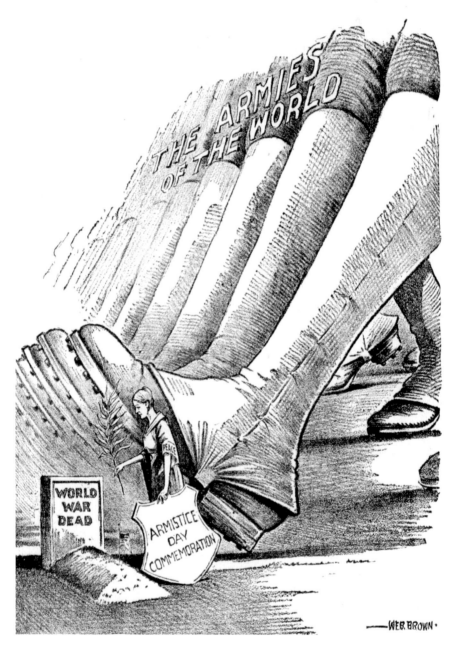

The world celebrates Armistice Day in 1938. *Reprinted with permission of the* Akron Beacon Journal *and Ohio.com.*

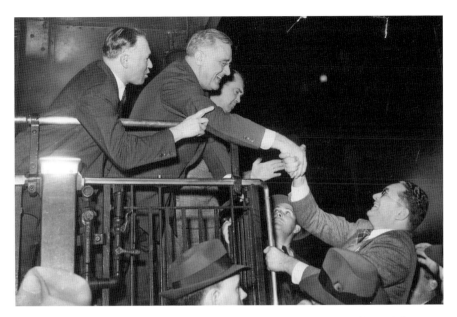

President Franklin Roosevelt shakes hands with Sherman Dalrymple, president of the United Rubber Workers of America, at Union Station. *Reprinted with permission of the* Akron Beacon Journal *and Ohio.com.*

President Roosevelt shakes hands with Akron congressman Dow Harter before speaking to a crowd at Union Station in Akron in October 1940. *Reprinted with permission of the* Akron Beacon Journal *and Ohio.com.*

Sixth Street. The armory inducted 145 Northeast Ohio men a day in the winter and spring of 1941. The Fort Hayes Reception Center began inducting selectees shortly after the Selective Service Act passed in the fall of 1940 and continued doing so until February 21, 1944, when it was closed. In his first letter to his then girlfriend and later wife, Betty (my grandmother), John Carroll wrote:

Sunday, March 2, 1941
10:30 a.m.

Dearest Betsy,

There is absolutely no question in my mind but that I am definitely in the army. Life has been hectic ever since we arrived in Cleveland yesterday morning. Dad took me to the bus + Link was there to bid farewell.

We arrived in Cleveland at 9:00 + started in immediately on the physical exam. I breezed thru the damn thing like nothing + next thing I knew I was fingerprinted + in the army. We were not allowed to leave the Armory + had to just sit around. We sat + continued to sit from noon until 7:30 P.M. just bored stiff. Finally we left for the depot. After sitting all day, we get on the slowest train in the U.S. + it took us 6 hrs to get to Fort Hayes [Columbus]. When we got here, they lined us up all 200 of us + examined us for colds + venereal diseases at 3:30 A.M. By that time we did not care whether we lived or died.

We finally got to bed at about 4:00 A.M. + we were told that if we wished to miss breakfast we could sleep until eleven. So what happens but at nine O'clock on the Sabbath morning we were rudely awakened + had to make our beds + clean up. Two other fellows + I were appointed to the task of keeping the John clean all day. This is the first chance I have had to write + it being Sunday I can't purchase a stamp to mail it.

Honey, I don't know where we are going. All I can tell you is that we will be here from two to five days + then shipped someplace else. Please write me here right away + maybe I will get your letter before we leave.

Write me to Company B Receiving,
Reception Center
Fort Hayes
Columbus, Ohio

You may now address me as Private Carroll.

I feel like I have been gone for years already + I miss you plenty even in this short time.

I think I'll take a short nap now, probably just get to sleep + some Sargeant [sic] will come in bellowing orders.

Only 364 more days,

All My Love,
Jack

P.S. If this letter isn't to coherent it is because I am so damn tired.

John Carroll signed his first letter "Only 364 more days" because before Pearl Harbor, draftees were required to serve for one year; then they could return to civilian life as long as the United States was not at war. But John did not get out of the army until 1945.

The first Akron boys leave for service in October 1940. Where will they be in a year? *Reprinted with permission of the* Akron Beacon Journal *and Ohio.com.*

The peacetime draft begins in October 1940. *Reprinted with permission of the* Akron Beacon Journal *and Ohio.com.*

Uncle Sam knows how to recruit as men register for the peacetime draft. *Reprinted with permission of the* Akron Beacon Journal *and Ohio.com.*

John's best friend, Jack Edward Link, came to see him off at the bus station in Akron. Jack Link was the son of Akron dentist Dr. Charles Link, who practiced at 172 South Main Street. In March 1941, John took a bus from the Ohio Edison Bus Terminal, which operated from 1918 to 1949 at 47 North Main Street.

March 1941 also saw passage of the Lend-Lease bill. A survey of students at the University of Akron and Kent State in January 1941, when the Lend-Lease bill was first introduced in Congress, indicates that there was not much support for the bill among the younger set. Many students expressed frustration at what they saw as President Roosevelt leading them to war against their wishes. Fifty-one percent of students favored aid to Britain, while forty-nine percent did not. Seventy-two percent of students expected the United States to enter the war, but the same percentage was against going to war to aid Britain.

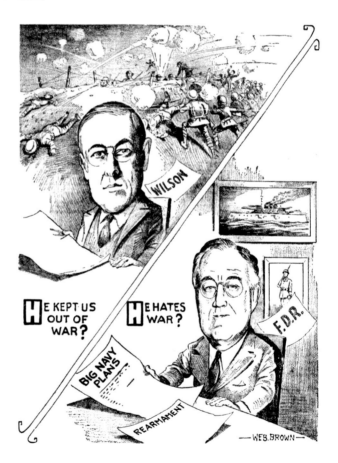

Both Woodrow Wilson and Franklin Roosevelt campaigned on keeping out of war. *Reprinted with permission of the* Akron Beacon Journal *and Ohio.com.*

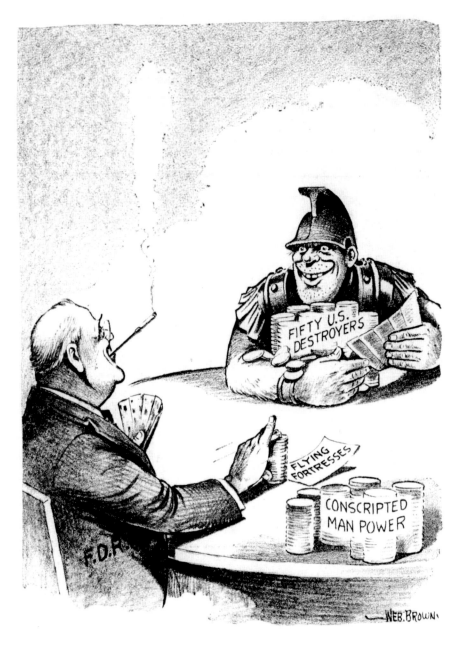

FDR and Mars play a game of poker. It won't be long before Mars gets the conscripted manpower. *Reprinted with permission of the* Akron Beacon Journal *and Ohio.com.*

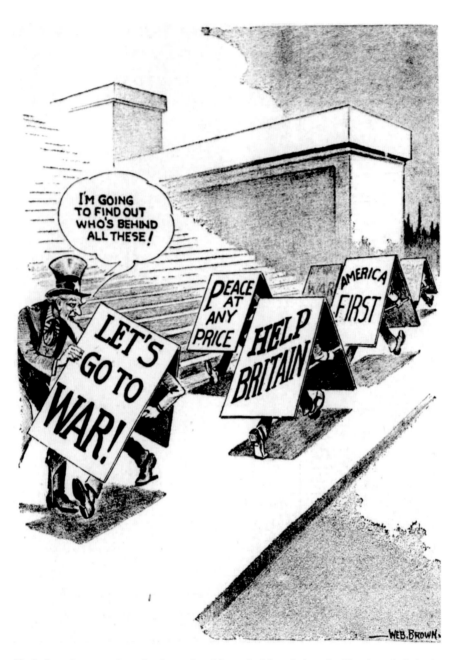

Uncle Sam does some investigating as Lend-Lease is debated. America First is an isolationist organization. *Reprinted with permission of the* Akron Beacon Journal *and Ohio.com.*

The students also objected to the use of convoys in the Lend-Lease agreement, even though FDR promised he wouldn't use convoys to protect merchant ships. Later that fall, FDR issued his famous shoot-on-sight order to protect American merchant ships from what he referred to as the rattlesnakes of the Atlantic—German U-boats.

An increasingly aggressive foreign policy by the Roosevelt administration was slowly removing the safeguards of isolationism to push America into the conflict. Americans spoke out against the Lend-Lease bill during the winter of 1941, and just like the Selective Service Act of 1940, FDR promised the American people it was only meant for defensive purposes in order to assure its passage in Congress.

FDR's actions had consequences. Private Adam Seitz was the son of Austro-Hungarian immigrants. He was a Purple Heart recipient after being wounded in the invasion of Sicily. He was later killed on February 25, 1944, at the age of thirty in the fight for Cassino, Italy. Before the war, as Congress debated aiding Britain, Adam and his family wrote letters to the editor of the *Beacon Journal*.

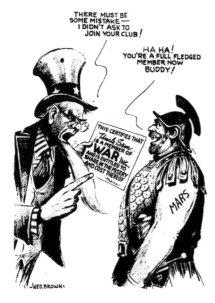

One of Web Brown's favorite characters, Mars, lets Uncle Sam know he just joined an ominous club when the Lend-Lease bill passes. *Reprinted with permission of the* Akron Beacon Journal *and Ohio.com.*

"I am against the repeal of the Johnson Act. Why should we help England when they owe us billions of dollars and do not make any attempt to pay us back? Let us think of America first. England would very much like to get us in the war, would they help us? I am afraid not." Adam's father and mother, Wendel and Eva, and his siblings, Frank, George and Mary, all wrote letters to the editor against the repeal of the Johnson Act in 1941 as well. The Johnson Act was a neutrality measure meant to keep America out of war by not providing loans to nations who defaulted on their World War I loans. A *Beacon Journal* poll on January 5, 1941, showed ninety-eight percent of Akronites were against repealing the Johnson Act to aid England. In the end, Congress passed the Lend-

Lease bill, providing much-needed aid to Britain, China and, later in 1941, Russia, amongst others. This aid may have kept Britain and Russia from falling to the Germans and China from succumbing to the Japanese. It also brought America closer to war, which was something the Seitz family and most other Akronites polled sought to avoid.

On June 24, 1941, Hitler invaded Russia, throwing a scare into the American government, and Congress began debating keeping the peacetime draftees in the army for two and a half years instead of the promised one year. The bill passed on August 12, 1941, and John Carroll was one among many not best pleased:

August 18, 1941
Betty Anne,

Congress has made it very clear that they want me for two more years. If I had the money + could afford it, I would go out tonight + get drunk.

While reading a paper the other day, I noticed an article on the draft bill. It told how the Ohio Congressman voted, in the house, 22 Ohio votes were against the extension + 2 voted for it. One of the two to vote for it was Dow W. Harter of Akron, Ohio. Dearest if you happen to have a chance meeting with him on the street, please spit in his eye + hit him on the chin for me.

Sweet I want you to be sure + read this week's Life Magazine if you have not already. It is dated Aug. 18 + has an article on the army. The Life reporter lived in a camp + quotes directly from the enlisted men. I have told you that the morale is low. Read that + you'll see what I mean. Everything they say is just how we feel.

Betsy I am ashamed of you too, giving away part of your hope chest just because of the bill. I know you won't do anything like that again, but I can't blame you for being mad. It certainly is a hell of a thing to pull on us.

Till Tomorrow
Jack

The *Life* article he refers to was "Life Reporter Finds Many 'Gripes' Have Lowered Army Morale." A reporter spent a week with an army infantry division made up of sixty percent National Guardsmen and forty percent selectees. Their commanding general said that morale was high, but fifty

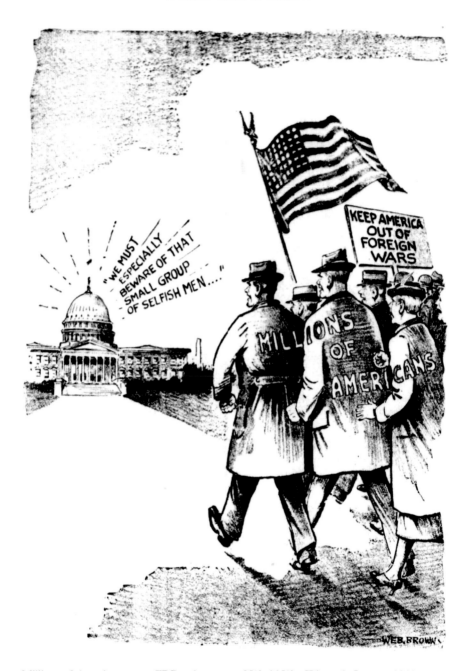

Millions of Americans want FDR to keep out of World War II in early January 1941 as Lend-Lease is debated. *Reprinted with permission of the* Akron Beacon Journal *and Ohio.com.*

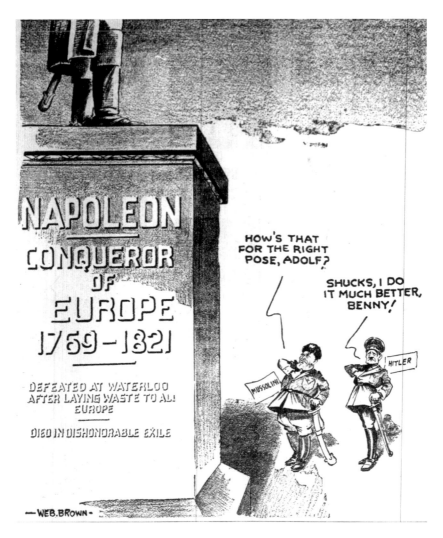

Web Brown reminds Hitler and Mussolini of the path they are on. *Reprinted with permission of the* Akron Beacon Journal *and Ohio.com.*

percent of the four hundred privates interviewed said they wanted to desert when their year was up in October—the reporter found "OHIO" written in various places all over the camp, which was an acronym for "over the hill in October." The phrase became popular throughout military camps as the draftees and guardsmen voiced their displeasure with the extension bill and threatened to desert. Only two men out of four hundred said they were interested in making the army their career.

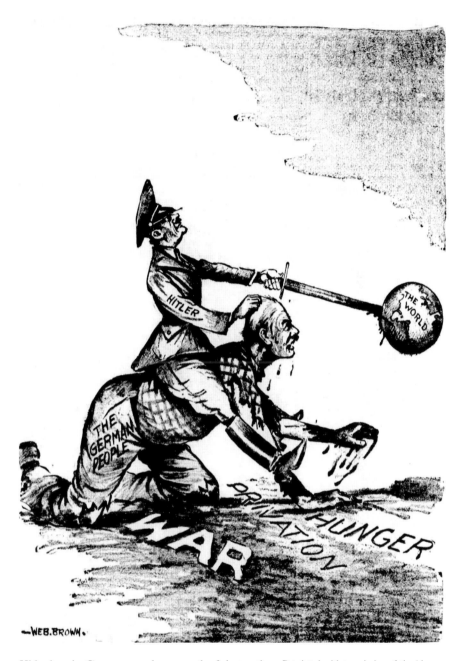

Hitler has the German people on a path of destruction. *Reprinted with permission of the* Akron Beacon Journal *and Ohio.com.*

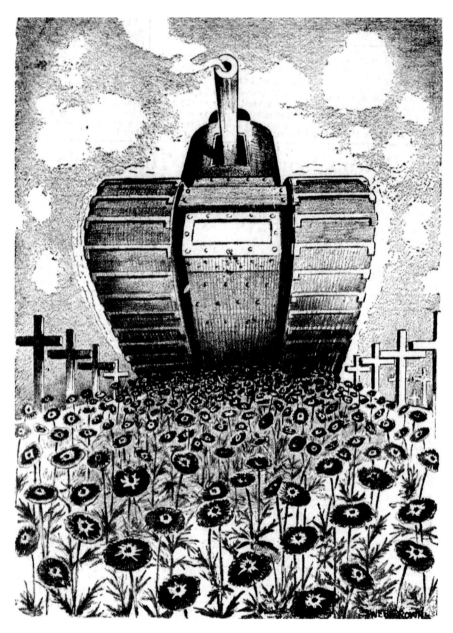

Web Brown references the powerful World War I poem "In Flanders Fields" on May 25, 1940, as France is invaded. *Reprinted with permission of the* Akron Beacon Journal *and Ohio.com.*

There were also strong anti-Roosevelt sentiments among the men, who felt like they were wasting their time. The men did not believe the national emergency was as serious as President Roosevelt indicated. It is plain to see that many of these men and their families likely voted against FDR and the Democrats in the 1942 midterm election as a result of their experience in the army.

Roosevelt was not the only politician to suffer the nation's displeasure. As Carroll noted in his letter, Ohio's Congressional representatives overwhelmingly voted against the bill extending the terms of service for the drafted men. Carroll's hometown congressman, Dow Harter, was one of two who voted for it. It passed the House of Representatives by a single vote. It's possible Harter bowed to pressure from the local rubber companies to pass the bill. They were concerned about the Japanese threatening their rubber supplies in the Pacific and reported that one hundred Akronites working overseas were in immediate danger if Japan made a grab for additional natural resources in the Far East. More importantly, ninety-seven percent of America's rubber supply came from the Far East. Harter was also a member of the House Military Affairs Committee and was expected to vote for the extension bill. He lost his seat in the next election after serving for ten years. Democrats on the whole lost forty-five seats in the House of Representatives in 1942 as Americans punished Roosevelt for leading them into the war they never wanted.

Life had a funny headline in August 1941 stating that Roosevelt had the Red Army fighting in defense of America. Yes, as long as the Russians were fighting the Nazis, there was no way the Nazis could attack America. Hitler had already abandoned invading Britain, and the fact that the ill-prepared and ill-equipped Russian army was fighting off the Germans was yet another sign that Hitler was losing the war. Hitler was not as great a threat to the American mainland as some historians have tried to indicate and likely had no ability to threaten mainland America at the time.

This and other articles showed extreme discontent amongst the drafted men. They complained about too many chores like latrine and coal duty with no practical training. They resented their inability to seek promotion while civilians were taking advantage of the booming war economy. They were also unhappy about the lack of recreational opportunities, with one pool for twenty thousand men. One soldier felt like he was living in a concentration camp, and another called George Marshall and the rest of the generals a bunch of liars for saying that their men were happy. One soldier pointed out that the Germans couldn't even cross the English Channel, questioning their

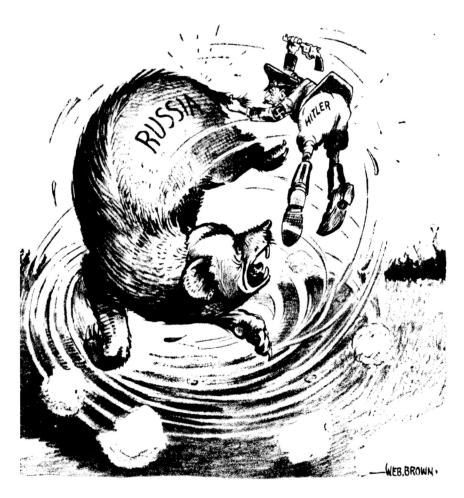

Russia continues to give Hitler problems throughout 1941. *Reprinted with permission of the* Akron Beacon Journal *and Ohio.com.*

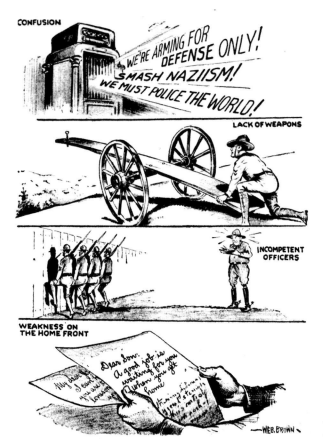

Morale problems in the army for the pre–Pearl Harbor soldiers. *Reprinted with permission of the* Akron Beacon Journal *and Ohio.com.*

capability to threaten the United States. The men said they had no chance at officer's training school and suggested the bums they had as officers get fired so they could get their chance. The men cursed the Germans, the British, the Russians, Roosevelt and General Marshall. On the brink of war in August 1941, Japan is not mentioned once in the article.

Following the sinking of the U.S. destroyer *Reuben James* on October 31, 1941, off the coast of Iceland by a German U-boat, the United States revised the Neutrality Act.

James Brantley Clark of Akron was killed when the *Reuben James* was sunk by German torpedoes. Willola Clark became the first Gold Star Mother of the war when James died at the age of twenty. Brantley's mother invested the $860 her son saved up in war bonds, hoping the money could be used to save lives by building better ships. "I even bought war stamps with the $1.71 premium on insurance," she said. "I wanted every cent of it to go towards

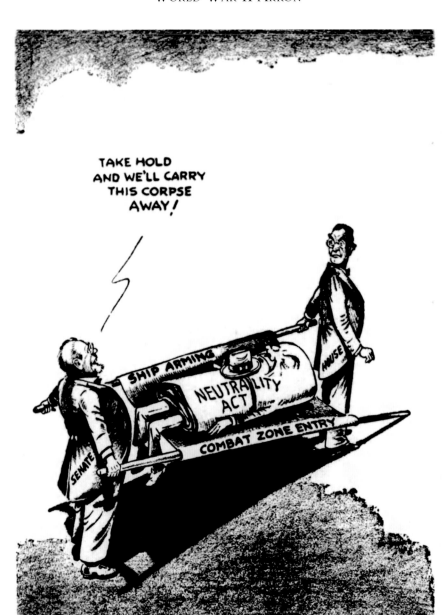

The Neutrality Act is dead as FDR successfully dismantles it throughout 1941. *Reprinted with permission of the* Akron Beacon Journal *and Ohio.com.*

winning the war." Charles Chester Hayes, the son of a World War I veteran, was on the *Reuben James* in early September and bounced around to two other ships before being put back on the *James* in October. Charles was not originally listed as being on the ship. His family held out hope that he had been transferred to a different ship and was still alive. That hope was dashed the next day when the navy notified the family that Charles had been aboard and was killed. He was nineteen.

Roman Hajoway of 935 Rowe Street was born in the Austro-Hungarian Empire and came to the United States in 1906, settling in Akron in 1908. He worked for Firestone Tire & Rubber Company, retiring after twenty-four years in 1953. During World War II, he had three sons and two daughters serve. The *Akron Beacon Journal* reported: "He said he had two regrets: that he was too old to fight and that there weren't more Hajoways to help." Roman's son Joseph Hajoway was on the USS *Reuben James* when the destroyer was sunk by a German U-boat. Joseph's mother, exhausted from crying, answered the phone shortly after midnight on November 4, 1941. It was a telegraph operator with a message from Admiral Chester W. Nimitz. Mrs. Hajoway handed over the phone, afraid her son had been lost on the *James*. It was good news, however: Joseph was rescued and uninjured. Margaret Benko, Joseph's girl, was also elated to learn he was still alive. Joseph married Margaret, the daughter of Czechoslovakian immigrants, on May 29, 1943, at St. Luke's Lutheran Church in New York City. Hajoway, a North High School honor student, worked for Goodyear Tire & Rubber Company for over forty years before retiring in 1985. He was married to Margaret for over fifty-five years. Joseph died on January 5, 1999, at seventy-eight. Margaret died on August 13, 2009, at eighty-eight.

The revision to the Neutrality Act on November 13, 1941, allowed American ships to carry supplies past Iceland and all the way across the Atlantic into war zones. This action by the American government angered the Germans and pushed the United States closer to war. This would have led to increased engagement between German U-boats and American ships. Though a limited naval war could have been fought against the Germans, one has to ask how long the American public would have tolerated ships being sunk and citizens being killed before they got more involved in the war. Convoying ships to Iceland and passing them off to Britain was working, so it could be argued that revising the Neutrality Act unnecessarily pushed the United States closer to war. But more dramatic, violent and tragic occurrences would push the nation over the edge.

PEARL HARBOR

The Japanese were known for attacking without warning, and some attack was expected at the time. Pearl Harbor was largely an intelligence failure, since the United States had enough intelligence to identify Pearl Harbor as the target. Most Americans were shocked by the attack, but it must be emphasized that the American government expected something. The American ambassador to Japan, Joseph Grew, warned the government on November 17, 1941, that the Japanese were planning an attack on Pearl Harbor. Grew himself found it hard to believe but reiterated that the information was from reliable sources. American civilians living on Guam were evacuated in November 1941, a sign that the American government anticipated a Japanese attack. Sadly, the warnings, the anticipation and the meager preparations amounted to nothing on the morning of December 7, 1941. Of the over two thousand men killed in the surprise strike, nine called Akron home: Andrew Danik (twenty-one years old), Wayne Presson (twenty-three), Howard Royer (twenty-two), Harold Edgar Summers (twenty-two), Robert Hunter (eighteen) and Peter Ott (twenty-two)—all on the USS *Arizona*—Bufford Dyer (twenty-four) and Thomas Zvansky (thirty-nine) on the USS *Oklahoma*; and Horace Messam (twenty-two), who was killed when a Japanese bomb hit his barracks at Hickam Field.

Congress declared war on Japan and waited to declare war on Germany. FDR had intelligence that suggested Hitler was going to declare war first— he was right. Hitler got the American people more fired up by declaring

war on them. Some say it was
Hitler honoring his 1940 treaty
with Japan, though he wasn't much
on honoring treaties. The revision
of the Neutrality Act in November
1941 and the continued aide to
Britain and Russia were perceived as
hostile acts in Germany and helped
provoke Hitler, who saw fighting the
United States as inevitable.

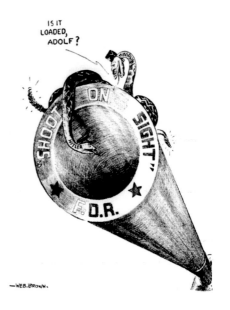

FDR played on the history of
World War I by embellishing attacks
by German U-boats on American
ships. Historians have accused
Roosevelt of attempting to use these
embellishments to enter the war.
Roosevelt hoped Americans would
support increased U.S. involvement
in the war effort, and he also wanted
to protect American supply lines.

The rattlesnakes of the Atlantic will now
be shot on site. *Reprinted with permission of the*
Akron Beacon Journal *and Ohio.com.*

Dramatizing U-boat attacks on American vessels was his way of loosening
the restrictions of the Neutrality Act—he needed justification to revise the
Neutrality Act or to give orders to shoot on sight. It is no coincidence that
the shoot-on-sight order was issued right after an embellished attack on the
destroyer *Greer* in September 1941. Concerned about the German invasion
of Russia earlier that summer, FDR wanted to protect and to get much-
needed supplies across the Atlantic to his allies.

Roosevelt was right to supply Britain and Russia with supplies, as they
used those supplies to keep Hitler in check on two fronts—or in FDR's
terms, "quarantine." Where FDR missed the mark was the fact that
he considered the threat to the United States greater in 1941 than in
1940. Germany had failed to defeat Britain in 1940 and invaded Russia
in 1941 hoping that a quick victory there could help it win the war. The
Germans had failed on two fronts by December 7, 1941. The British had
no immediate plans to invade Europe without American help. As during
World War I, the United States likely needed to enter the war to break
the stalemate.

That leaves Japan, a nation that had no plans or ability to invade the
United States. However, an American, British and Dutch oil embargo

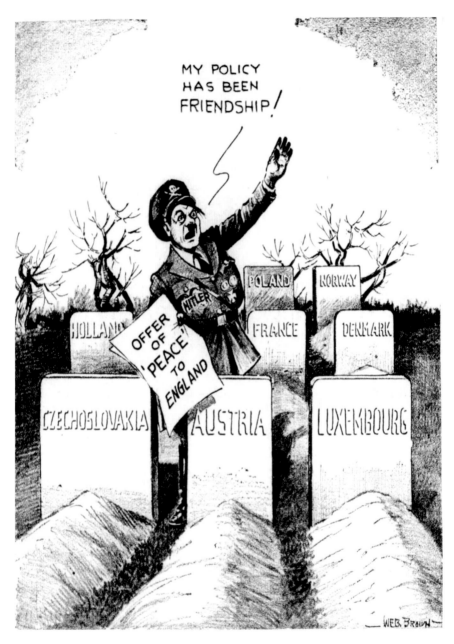

Hitler makes a peace offer, and when he fails to invade Britain, he sets his sights on Russia. *Reprinted with permission of the* Akron Beacon Journal *and Ohio.com.*

against Japan was working—Japan had enough oil reserves to last for two years, so it either had to give in to American demands in 1941 or attack. The longer it waited, the less oil it would have to wage war.

Japan's prime minister, Prince Konye, attempted to meet FDR for peace talks in the Pacific in the fall of 1941, but Roosevelt refused. There was not a sincere attempt to negotiate a peace settlement on Roosevelt's part even if the same could be said of Japan. Japan was willing to give in to most American demands. It was willing to leave Indo-China (Vietnam), which it had invaded in July; it was willing to agree to a halt in the fighting with China; and most importantly, it was willing to abandon the Axis Powers to get the embargo lifted. The Tripartite Pact between Germany and Japan was made out of mutual fear of the United States. There was no way Japan could trust Hitler, a man who was notorious for going back on his word and believed in the racial superiority of his people over all others. Japan was more than willing to leave the Axis Powers, which would have further weakened Hitler's position. That, however, was not enough for FDR—he also asked the Japanese to withdraw from China. While the Japanese were willing to consider a halt in the fighting in China combined with the other concessions, a Japanese withdrawal was too much in their eyes.

The Japanese attack on Pearl Harbor was more an act of desperation. The Japanese felt they were backed into a corner, and knowing the United States would likely fight if they invaded the Dutch East Indies for the natural resources they needed, the Japanese decided to attack the American fleet at Pearl Harbor. They hoped they could delay an American attack long enough to get the natural resources they needed and build up their defenses and that America would not be willing to wage a bloody war.

Admiral Yamamoto stated that if the war went longer than six months to a year, he could not be confident in a Japanese victory. He also is credited with the famous quote, "I fear all we have done is to awaken a sleeping giant and filled him with a terrible resolve." The Japanese did not have much confidence in their ultimate victory and instead attacked a nation they knew would likely defeat them rather than cave in to what they saw as unreasonable demands. The Battle of the Coral Sea in May 1942 was seen as a tie, and one month later, the Japanese were routed at the Battle of Midway. Yamamoto's prediction came true: after six months, despite their attack on Pearl Harbor, the Japanese were well on their way to being defeated.

If Japan had agreed to leave the Axis Powers, Hitler would have been left with one weak ally as he waged a failing two-front war. The Italians were as bad on the battlefield as the Germans were good. While the Germans went

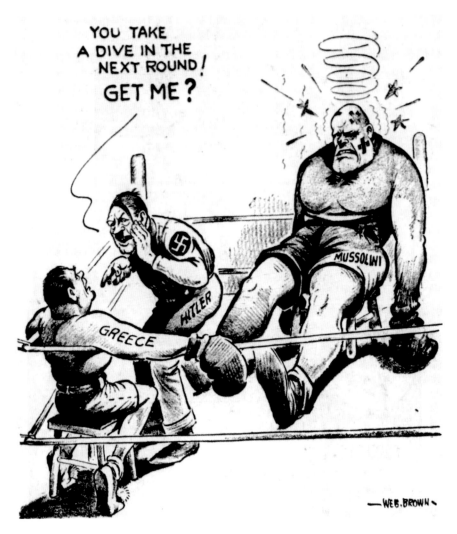

Mussolini wasn't much of an ally; Hitler typically had to bail him out of trouble. *Reprinted with permission of the* Akron Beacon Journal *and Ohio.com.*

all the way to Paris, Mussolini's troops, who also invaded France, managed to conquer the length of a football field. From Ethiopia to Greece, the Italian army struggled to find success. The question remains, if Japan did not attack the United States at Pearl Harbor, how would the United States have entered the war? Would German U-boat attacks have been enough to draw them in? We will never know. But we do know that on December 15, 1941, the Bill of Rights celebrated its 150th birthday as America prepared to defend it.

THE DRAFT

The Boy Scout Draft

The end of June 1942 brought the registration of 2,500 Summit County men ages eighteen to twenty and a half, or those born between January 1, 1922, and June 30, 1924.

In October 1942, the draft age was lowered, allowing eighteen- and nineteen-year-old men to finish the school year if they wished; after July 1, 1943, no deferments were given to attend school. Congressmen fought to get a provision put in the draft bill that lowered the age from twenty to eighteen that these young men be given twelve months of training before being sent overseas. The army had sent some soldiers overseas with less than thirty days of training, outraging some congressmen, and they wanted to make sure these young men were adequately trained. The army rejected any restrictions, and no mandatory training period was ever put in place. The drafting of eighteen-year-olds—or as many called it, the "Boy Scout Draft"—was used to delay drafting men with children. America was short on manpower, and to delay putting fathers on the front lines, Congress chose to lower the draft age. A year later, when America was faced with drafted fathers, Congress talked of lowering the draft age to seventeen. It was seriously debated for months, but the draft age was never lowered. Faced with a tough choice, America sent fathers into war instead. Robertus Holden, a Civil War veteran who had enlisted in the Union army at sixteen, had this to say on Memorial

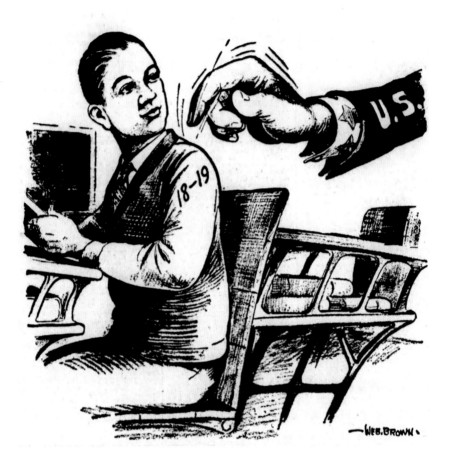

America looks to draft the kids from the classroom to avoid drafting fathers early in the war. *Reprinted with permission of the* Akron Beacon Journal *and Ohio.com.*

Day, 1942, at the age of ninety-six: "The Civil War was fought by boys and now they're talking about getting boys into this war."

The first local casualties from the Boy Scout Draft came in the American theater. Richard W. Morris was killed at Camp San Luis Obispo in California on June 7, 1943, at eighteen in an auto accident. Harry Sawyer Jr. was killed at nineteen at Fort Lewis on the same day after being drafted in February. Private First Class Anthony Perrotta, a 1941 South High grad, was killed in Mississippi at nineteen on June 27, 1943, after being struck by lightning. These noncombat tragedies caused the same amount of suffering for families. The Sawyer family, for instance, lost their only son and later published this tribute in the *Beacon Journal*:

In Loving Memory
Of Our Beloved Son
P.F.C. Harry M. Sawyer, Jr.
Who Passed Away
One Year Ago Today
Our lips cannot tell how we miss him.
Our hearts know not what to say:
God alone knows how we miss him
In a home that is lonesome today.
Deep in our hearts lies a picture
Of our loved one we laid to rest.
In memory's frame we shall keep it,
Because he was one of the best.
 Mother and Dad.

The first local casualty overseas occurred on October 25, 1943, when Private Harold Shepherd died in Iceland two days after his nineteenth birthday. Private Richard Allen Dixon was one of ten kids. He was drafted while he was still a student at Central High School. Overseas for three months, he was killed at nineteen on May 12, 1944, in Minturno, Italy, at the battle for Rome. Richard's little brother Private First Class Wayne E. Dixon was killed at twenty-two on May 18, 1951, in Korea. Veterans of Foreign Wars Post Roger Moore was named for his uncle, who was killed in World War I.

Tech Sergeant William Laslo was the son of World War I veteran Stephen Laslo, who crippled his arm during the Battle of the Argonne on September 26, 1918. William, the radio operator of a B-24 Liberator bomber, was killed on a mission in Europe on June 4, 1944, two days prior to the D-day invasion. Overseas since April, William had just turned twenty-one. "Why do these nineteen- and twenty- and twenty-one-year-olds have to be sacrificed in this wholesale slaughter?" Stephen Laslo asked upon learning the news of his son's death. Unfortunately, the slaughter was only starting. Of the 1,571 Akronites killed in World War II, just over 1,000 died between June 1, 1944, and the Japanese surrender on September 2, 1945. Over 80 young men from Akron have been confirmed killed as part of the Boy Scout Draft.

Private Edward H. Stewart was drafted in March 1943. He was killed on June 24, 1944, nine days after his twentieth birthday, in the battle for New Guinea. When his family was notified of his death on July 15, 1944, his grieving mother put their flag at half-staff outside their Pitkin Avenue home. She asked a reporter, "Do you think it's all right? Edward died for

his country." Sergeant Alfred E. Averill Jr. was killed in Normandy, France, on July 26, 1944, at nineteen. He was president of his class at Copley High School and an only child.

Private First Class Fred H. McMullen was a 1943 East High grad. Fred's mother, Naomi Leiter, left her house to go out to dinner to celebrate her birthday in October 1944 and decided to check out the unusual number of letters in her mailbox. The letters to Fred fighting in France were sent back to her and marked with both the words "deceased" and "missing." The stunned mother looked up as she sat on the porch and saw a telegram boy coming up the walk. The telegram handed to her said her son had been killed on September 17, 1944, in France at nineteen.

Private First Class Edwin Byron was drafted on May 10, 1943, before graduation at East High School and wanted to be a pilot in the Army Air Corps. After crashing a training plane in California, he was told he was too nervous to fly. The disappointed soldier headed to the infantry and overseas in September 1944. He was killed in France on March 20, 1945, at twenty. He left behind his wife, Margaret, and a sixteen-month-old son who was named after him.

Private Harold L. Moneypenny was killed on January 6, 1945, in Belgium at eighteen after being overseas only a week. He attended North High School. His younger brother Charles wanted to join the navy immediately to pay the Nazis back for killing his brother.

Sergeant Glenn D. Brooks was an East High School grad and draftee who was home on furlough when he sprinted back up the stairs just before he left. He told his mom he wanted to take one last look at his room. In Europe, Brooks faced tough battles everywhere he went. He first saw combat on the Anzio beachhead. Glenn made it through unscathed and celebrated his nineteenth birthday in Rome. After Anzio, Glenn received severe leg wounds in October 1944 fighting through Southern France and won a Bronze Star, Purple Heart and Combat Infantryman's Badge. Germany's surrender was a month away when the Eagle Scout was killed in Germany at nineteen on April 8, 1945, after fighting overseas for thirteen months. Glenn's grieving mother said she would never change the room that her boy loved so much and where he spent his happy childhood building things and hanging pictures of what he loved.

Staff Sergeant James Richard Clapsaddle was a senior at Central High School when he was drafted. He was killed in Italy on August 10, 1944, at nineteen. Private First Class Jack Guthrie had never been separated from his twin brother, Joe, until he was drafted in March 1943 at eighteen. Jack was

wounded at Anzio and spent months in a North African hospital before he went back into battle. He was killed at nineteen in Italy.

Tech Sergeant Edward Jay Harter was a St. Vincent High grad drafted at nineteen. He was killed at twenty-one on a mission over the Adriatic Sea on February 16, 1945. He was a radioman on a Flying Fortress; when his plane and another collided, eighteen men died. He was the only son of former Akron mayor George Harter, who died in the spring of 1945 not knowing what happened to his son. Mayor Harter's wife didn't tell him Eddie was missing in action while he was in the hospital. Friends pretended Eddie was on his way home to boost his morale. Mayor Harter's wife said, "I have a feeling my husband really knew deep in his heart that something was wrong. Once he said to me, during the last days of his life, 'You know I don't think Eddie's coming back.' " Edward Harter had a wife, Lois, and his son, Edward Jr., was born the day after he was killed.

Private First Class George F. Klein wrote home, "I've only been in action a little while but I've seen things to make me almost sorry I'm a member of the human race. The trouble with most American civilians, is that we take things like baseball games, canoeing on the Portage Lakes, our nice homes and our American rights too much for granted." He closed his last letter home with thoughts of his parents and dog: "All I want is for you and Daddy and Rusty to be there when I get back." He was killed at nineteen on June 17, 1945, on Okinawa, where his friend George Grant was also killed in action.

Private Edward L. McAlarney, of 368 Ira Avenue, was drafted while he was still in high school. The former East High School student and Goodyear worker had been overseas for six weeks late in the European war when a German sniper ended his life on Easter Sunday, April 1, 1945. He was eighteen.

Private First Class John Herbert Matthews Jr. was the son of a rubber worker and attending Central High School when he was drafted. In July 1944, he had the top rating of his company on the rifle range. John was sent overseas with the Ninety-Ninth Infantry Division in September 1944 and died in Linz, Germany, on March 16, 1945, at nineteen. The truck he was driving was hit with an anti-tank rocket, and he helped two soldiers escape before being killed. A year later, he was awarded the Silver Star. On his last furlough home, John had left one of his army hats, and his broken-hearted eleven-year-old brother, Robert, wore it to school on April 5, 1945, upon learning his older brother had been killed in action. The boy would go on to be a distinguished music professor at Edinboro University of Pennsylvania. Robert died in 2010.

Time is running out as Congress gets ready to lower the draft age. *Reprinted with permission of the* Akron Beacon Journal *and Ohio.com.*

Private First Class Harold W. Taylor was a 1943 Garfield High grad drafted on July 4, 1943. He had made it through the battlefields of Europe, receiving shrapnel wounds to the head in January 1945. "I went to the door with the queerest feeling that I would find Harold there. Instead it was the telegraph boy," recounted Harold's mother. He was killed in a vehicle accident as part of the army of occupation in Germany on June 21, 1945, at twenty. Harold had written to the *Beacon Journal* before he died, and his letter was published on July 5, 1945, a week before the telegram announcing his death came to his mother's door:

> *Words cannot express how glad I was to receive your Rotomagazine which devoted its entire section solely for the purpose of giving us in the service a good look at our hometown. Not only have you given us a once-over of that long-for place. Memories and letters are all that we have to keep up our spirits until we actually are home again.*

Congress acted in late April 1945, and in June, the military was required to give men under the age of nineteen six months of training before sending them into combat. Up until that time, during the bloodiest fighting of World War II, eighteen-year-olds were regularly sent to the front lines with three or four months of training.

OLD MAN'S DRAFT

On April 25, 1942, over forty thousand Summit County men ages forty-five to sixty-four and over seven hundred thousand Ohioans went out to register for the fourth draft registration during the three-day registration period. The *Beacon Journal* referred to this class as the leadership class; it included President Roosevelt and General Douglas MacArthur. Many World War I veterans and even a few Spanish-American War veterans were among this group. It was unlikely that these men would be called to fight, but as early as 1942, a labor draft was talked about. This age group would also have been considered for noncombat roles. The U.S. government wanted to see what skills members of this age group had and what men ages forty-six to sixty-four were available for defense jobs so younger men could be used in the armed services. On the other side of the pond, on April 25, 1942, sixteen-year-old Princess Elizabeth became one

The Old Man's Draft of 1942. *Reprinted with permission of the* Akron Beacon Journal *and Ohio.com.*

of two hundred thousand English girls to register in a youth registration in England.

In March 1943, five thousand Akron men ages thirty-eight to forty-five were put back into the draft. Single and married men of this age group who did not hold essential jobs faced induction. The reason for this is that the government was desperate for farm labor. The men in this age group were

told they had until May 1, 1943, to find a farm job to avoid being drafted. By September 1943, twenty thousand Akron men had been drafted, and over twelve thousand men and women had volunteered.

The Akron area was so desperate for farm labor that the *Beacon Journal* published the following plea:

Everyone Can Help

Ohio's old age pensioners, physically able to work are urged to help harvest this year's crops. Their pension payments will not be affected by any extra earnings they receive for farm labor. High Schools are arranging classes to permit teen-age youths to work in war plants. There is no age limit on helping to win the war.

DRAFTING OF FATHERS

The drafting of men who were fathers before Pearl Harbor started in the fall of 1943. The deadliest years of the war were 1944 and 1945, and as fathers were being drafted, they were being sent into some of the bloodiest battles of the war. There were no exceptions or efforts to keep fathers off the front lines. In October 1943, thirty-eight states reported they would start drafting fathers. Board Number Eight in Akron reported it had exhausted its draft list. It would get six to eight boys per month who had turned eighteen, another six whose deferments had expired and several others. The rest of the board's quota would have to be fathers. By July 1944, as many as one million pre–Pearl Harbor fathers could be drafted, and every physically fit pre–Pearl Harbor father up to the age of thirty-eight could be taken.

Three local draft boards in Akron reported that they would have to start drafting fathers in October 1943, while the rest hoped to hold off until November. Board Eight planned to draft ten fathers, Board Four six and Board Fourteen, which covered Summit County south of Barberton, twenty-five in October 1943. In Columbus, Major William Averill, the executive officer at state selective service headquarters, had this to say: "The reports from local boards that fathers will not be called mean one of two things, either the boards have uncovered a lot of available 1-A's they did not know they had or the calls will not be met in full." He warned local draft boards that if they did not meet their quotas because they did not draft any fathers in October,

they would have to make up the difference in November by drafting more fathers. It seemed futile, as just about every draft board in the country was reporting it would have to start drafting fathers by November. The task was not easy for local draft boards. Some attempted to delay, hoping Congress would intervene. Some board members across the country threatened to quit. Some in Congress suggested the draft age be lowered to seventeen instead.

In November 1943, Guy E. Weiler, a father of seven children ages five to sixteen, was classified 1-A by his Wayne County draft board, and he was drafted in December 1943. The number of children and their ages did not keep fathers from being drafted. Only extreme hardship to their family could do so. Fathers were given preference over men who had parents or siblings dependent upon them. Post–Pearl Harbor fathers were drafted before pre–Pearl Harbor fathers.

Chester S. Endress, born in Hungary and in the United States since the age of two, was the father of children ages three, six and nine and was a driver for a brewing company. He believed he was being drafted because he made the mistake of switching from driving coal for his company to driving for the brewery part of the business. He was no longer considered essential. Chester's mom, wife and three kids would have to pay the bills without him by using the $95 a month he'd get from the government.

The following are brief accounts of Akron-area fathers who were drafted during World War II and killed in action. It's important to remember that these patriotic soldiers were forced to leave their wives and kids and head overseas, often participating in the worst violence any human being can experience. America often celebrates the exaggerated fact that everybody joined up to fight after Pearl Harbor; largely forgotten are these men who did not volunteer but whose families were left devastated by their ultimate sacrifice for their country.

On July 26, 1943, Private First Class William Fred Abshire, a former Garfield High basketball player and 1932 graduate, was drafted into the army. The son of widowed Grace Abshire, William—who always went by Fred—wrote home that his feet and hands were frozen for a second time and that he was now in Belgium. Doctors said his infected feet would recover after he kept them warm awhile. When they did, he was sent back into action. He was killed on March 2, 1945, in Cologne, Germany, at the age of thirty-one. He left behind his wife, Dorothy, five-year-old son David and two-year-old daughter Darlene. Always praying that his dad would return, David told his broken-hearted grandmother, "But Grandma, I said my prayers every night that Daddy would come back."

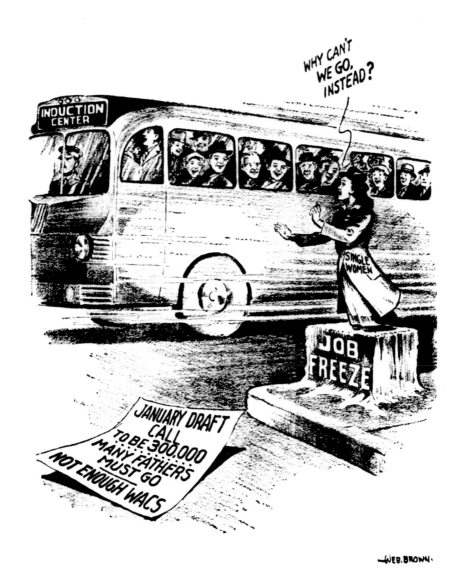

Fathers must go! Dad is sent to war, and many Akron area fathers are killed in action. *Reprinted with permission of the* Akron Beacon Journal *and Ohio.com.*

Private Rome Collins was a former tank department employee at B.F. Goodrich with four small children, Ralph (six), Lucy (four), Alma (two) and Sandra (three months) and a wife, Ila. After a final furlough home to Akron, Rome, a draftee, left for overseas duty on March 2, 1945, as the war in

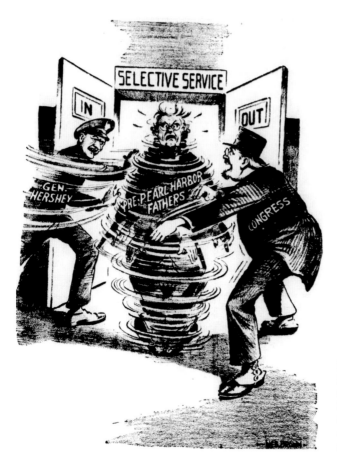

Pre–Pearl Harbor fathers face confusion on when they will be drafted. *Reprinted with permission of the* Akron Beacon Journal *and Ohio.com.*

Europe was in its final stages. He was killed in Germany on April 14, 1945, at twenty-five.

Private First Class Walter M. Brumbaugh, a 1932 North High School graduate, was listed as missing in action on Christmas Eve, 1944, in Luxembourg. Walter's three-year-old son received his last letter home around the same time the telegram came informing Robert's wife and son of his death on December 28, 1944, during the Battle of the Bulge. "Can't daddy write me anymore?" he asked his mother, Dorothy. She shook her head. "We didn't say our prayers enough I guess," the little boy sobbed.

Sergeant William Herr was a 1933 North High School graduate and close friend of fellow North graduate Walter Brumbaugh. William and Walter were both drafted fathers. In his last letter home to his wife, Geraldine, William wrote, "I'm getting closer and closer to Walter. I wish I could find a warmer place to write—my hands are about frozen. I close my eyes and think

of those wonderful moments we are going to have in front of our fireplace. Your letters thrill me because I know you are longing for me just as much as I am desperately trying to return to you." Hours after Geraldine received the letter, a telegram arrived. After surviving thirty-five straight days of fighting during the Battle of the Bulge, William was killed in France on February 4, 1945, at twenty-nine. He left behind his wife and four-year-old son, Bruce. William's mother, Cathy, lost her only child.

Staff Sergeant Harry Glenn Dunbar Jr. was a Kenmore High grad killed at twenty-nine on September 19, 1944, on a mission over Holland. He left behind his wife, Elizabeth, and three daughters, Ruth (seven), Dolores (five) and Florence (two and a half). He was employed by Lucco Trucking Company before being drafted and had only four missions left before he could come home. "Three Girls Are Left Fatherless," the headline read.

Staff Sergeant Albert H. Johnson was a Central High grad killed on May 24, 1945, at forty-five in Germany. He lived with brother, wife and fourteen-year-old foster son William. He had been overseas eleven months and in the army three years. William was drafted before the age law went in effect. He graduated from the University of Akron and Western Reserve Law School and was assistant law director for Mayor C. Nelson Sparks and police prosecutor for May Lee Shroy.

Private First Class Lawrence W. Kuntz was drafted on December 8, 1943, and killed a year later on December 17, 1944, at twenty-seven in France. He and his wife, Kathleen, had three kids: Mary Louise (three), Jean (two) and baby Larry Jr.

Corporal Alexander Lengyel Jr. was drafted on June 5, 1943, and was in the field artillery. In February 1945, his wife, Ellen, received a call at the bakery where she worked from a neighbor saying a telegram had arrived. Alexander had been missing in action, and Ellen said to herself, "Please make it good news" as she walked home from work. When she arrived, her daughter, Marjorie Ann, almost two, handed her the telegram. Ellen broke into tears and collapsed upon reading that Alexander had been killed on December 17, 1944, in Belgium when the Germans massacred over one hundred captured soldiers at Malmedy. He was twenty-seven.

Private First Class Gary L. Milbry was the first African American from Akron to die in Europe. He was killed in Belgium on February 2, 1945, at twenty-five. He left behind his wife, Anna, and son, Lee Otis.

Private First Class William Charles Packan was a Garfield High and the University of Akron grad. He taught science at Mason Elementary School for five years before leaving to work in the marketing research department

at Firestone Tire & Rubber Company. He was almost finished with his doctorate degree in psychology at Western Reserve University when he was drafted on June 9, 1943. He was married to Charlotte Hayes, who was the daughter of University of Akron psychology professor Dr. George Hayes. William was killed on December 27, 1944, in Luxembourg at thirty-three. He left behind a two-year-old son, Nicholas, and a five-month-old boy, Gregory, whom he last saw on furlough when he was born just before William headed overseas.

Private John Grant Putnam was killed on October 24, 1944, in Italy at thirty-three. He left behind his wife, Naomi, and children Eugene (twelve), Donald (nine), Eddie (six) and Richard and Carolyn Sue (both four). He was drafted in February 1944 and sent overseas in August. In October 1956, the family was notified by the military that a farmer had found a body while plowing his field in Castel San Pietro, Italy. "White-haired and frail, Mrs. Frances Alice Putnam, 82, the soldier's mother, broke down and wept for hours after the call," reported the *Akron Beacon Journal*.

Private Robert E. Townsend was the oldest son of six boys and one girl born to Carl B. and Enid Townsend. Carl spoke over the phone to a reporter and said, "I want to report my son Bob missing in action." His voice was tremulous and hesitant. Suddenly the reporter on the other end of the line could hear rapid movements and raised voices. Someone shouted "Dad! Dad!" After a few moments' pause, Carl's voice was again heard on the telephone. "I am sorry to have kept you waiting," he choked. "A telegram just came saying Bob was killed in action. His mother just fainted." Bob's commanding officer wrote the family to tell them he was buried in Holland and that the radio operator was one of seventy-nine men they lost on November 18, 1944, including three officers. The South High grad was a member of the Red Ball Express. He left behind his wife, Lucille, and three-year-old daughter Phyllis. He was twenty-three.

In August 1945, as the Japanese appeared ready to surrender, the draft was suspended for those ages twenty-six and older. A group of fifty-one men was ready to board a train to Cleveland for induction and was in the process of saying goodbye to their families when Earl Slack, chairman of Draft Board Five, broke the news. Only ten in the group ended up heading for Cleveland—nine eighteen- and nineteen-year-olds and one volunteer. The headline in the *Beacon Journal* read " 'Overage' Dads Snatched from Draft at 11th Hour." Goodbye tears suddenly turned to tears of joy. "Our daddy's coming home again, cried Earl Rhodes, 5, and his sister, Sherrell 3. They threw themselves in the arms of their father, Irvin Rhodes, 28,

while their mother wept openly at the news that the Firestone State garage employee didn't have to leave after all." Michael Terranova celebrated at Union Station with his son Michael Jr. and daughter Catherine, along with Charles Cottle and his son Frank.

Fathers were not out of the woods yet. The government did not send home fathers who had been drafted and were still in service. One of the last Akron-area fathers killed in the war was Private Donald L. Lemaster, who was killed on November 16, 1945, at the age of thirty when a storm knocked him from the deck of a transport ship in the Atlantic on his way overseas with the army of occupation. He left behind his wife, Marie, and five-year-old daughter, Donna. In all, at least 192 Akron area fathers died in World War II, including 3 drafted fathers with 5 children. Some fathers volunteered, many were drafted and quite a few volunteers and draftees got married and had a kid after entering the service. It was common for men to die in action without ever seeing their children, and kids were often born after their fathers were killed in action.

There were some happy endings. Sergeant John D. Collins was reported killed on December 23, 1944, at thirty-six during the Battle of the Bulge. John's name appears on the list of 1,600-plus Akron-area men killed in service published in the *Beacon Journal* on May 30, 1945, as part of the Memorial Day celebration. News that their father was still alive and recovering from wounds received in battle was received by Collins's seven children on Father's Day, 1945. Collins was later awarded a Purple Heart.

There were no soldiers at the door to break the news to families that their loved one was killed, prisoner of war, missing or wounded—it was always a telegram. Families occasionally learned of a family member's death by letter from a friend or commanding officer or through the horrible experience of having a letter they sent return to them marked "deceased." Many area mothers and wives reported being terrified at the site of the telegram boy at their door.

CONSCIENTIOUS OBJECTORS

Conscientious objectors were treated better in World War II than in World War I. During World War I, fourteen conscientious objectors were sentenced to death, and many were given lengthy prison sentences unless they belonged to religious groups known to be opposed to war. The death sentences were

never carried out, and many objectors were released by President Harding after the war.

Still, during World War II, Henry Weber, from Vancouver, Washington, was married and a father of a three-year-old son. He wanted to serve in the medical corps, and when he refused to pick up a gun, he was sentenced to hang. Henry's sentence was later reduced to five years in prison, and the American Civil Liberties Union continued to push for his release, asking that he be allowed to join the medical corps.

Locally, Holmes County's Amish and Mennonite population accounted for forty percent of Ohio's conscientious objectors in the early days of the draft in 1941. Objectors who refused noncombat duty in the army had the option of working on the home front. Some were smokejumpers out west fighting forest fires. Farmers throughout the country, Northeast Ohio and Summit County used objectors to help on their farms, since many farmers were drafted or left to work in defense factories. Local farmers were allowed to import help from areas like Kentucky but had to show that housing was available for them. In 1943, Summit County had no housing available, as war workers already had taken it all up. Conscientious objectors were the best option for local farmers.

In October 1940, when the government first started drafting soldiers, young Akron men of the Seventh-day Adventist faith began on their own training a group of twenty-four men to be medics in the army every Sunday. A medic, Private First Class Desmond Doss of Lynchburg, Virginia, became the most famous Seventh-day Adventist of the war when he won the Congressional Medal of Honor after lowering seventy-five men to safety from a cliff on Okinawa under heavy enemy fire. Doss stayed at the top of the ridge even after his commander ordered him down and calmly lowered the men to safety. He was under such intense enemy fire that his outfit, the Seventy-Seventh Division, threw all 1,250 grenades it had to keep the Japanese at bay. The 2016 Oscar-winning film *Hacksaw Ridge* was made about Doss's heroism, though it inaccurately portrayed him as a volunteer when he was drafted into service.

It is said that Desmond Doss could have gotten out of the draft because he held a defense job but chose to serve rather than challenge the draft. Many Akron men who were killed in action held defense jobs in rubber factories or at Goodyear Aircraft Corporation before being drafted. A defense job was not a ticket out of service—you had to be absolutely essential. As the war went on and America was drafting fathers by the end of 1943, every single man who could be spared from the defense plants was most certainly being

taken. Many men, even if they were fathers or defense workers, chose not to fight the draft and go into the armed forces.

The most common conscientious objectors to go to prison during the war in Northeast Ohio were Jehovah's Witnesses who refused induction. They claimed selective service exempted all ministers of the gospel. In January 1944, nineteen-year-old Ernest Sarka of Barberton, nineteen-year-old Francis Watkins Jr. and eighteen-year-old Dale Maurer of Akron were sentenced to five years in prison. A twenty-four-year-old bus driver for Akron Public Schools, Ernest Tresidder, was suspended by superintendent Otis C. Hatton for not reporting for induction. On December 23, 1946, Americans dressed as convicts marched outside the White House demanding that the nation's 475 conscientious objectors still in prison be released as a goodwill gesture during the Christmas season. President Truman later announced the pardoning of 160 conscientious objectors. Men and women interviewed by the *Beacon Journal* agreed that conscientious objectors were standing up for their beliefs and had been in jail long enough.

THE HOME FRONT: AKRON MOBILIZES FOR WAR

Akron Joins the Fight

Just prior to Pearl Harbor, there were 42,000 rubber workers in Akron. Fast forward to October 31, 1942, and Akron employment in the rubber factories was a record-setting 70,600, just above the previous record of 70,073 set in 1920 during the World War I industrial boom. Akron had been called a ghost city during the Great Depression due to its population declining throughout the decade, but it began to rebound by 1940. In April 1940, the census put Akron's population at 244,791, down from 258,384 in 1930. In October 1942, the population of Akron was estimated to have increased by 34,112 for a total of 278,903.

Actress Marlene Dietrich came to town along with a military escort of ten jeeps to help raise $200,000 in war bond sales. Jeep rides were given for the cost of a $25 war bond, accounting for $10,000 in sales. Dietrich rode all over town with her jeep escort and twenty college-aged Akron women—the "minute maids"—aiding her in selling bonds.

The sales of war bonds after Pearl Harbor started strong with $1.061 billion in sales in January before slipping to $703 million in February and $565 million in March. Bond sales continued to slip in April 1942, when the U.S. Treasury finally set national and statewide goals for selling war bonds to the public. It was also announced that each community would soon have its own goal to reach in war bond sales. Summit County's Third War Loan

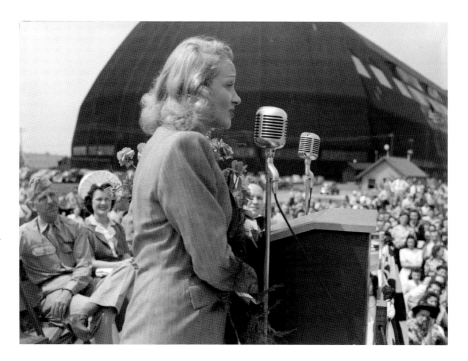

Actress Marlene Dietrich gives a speech encouraging workers to buy war bonds in front of the Goodyear Airdock on Jeep Day. *Goodyear Tire & Rubber Company Records, Archival Services, the University of Akron, Akron, Ohio.*

drive quota was $26.5 million, and the county raised $41,851,823, finishing first out of twenty-six counties in Northeast Ohio. Summit County turned in 152.4 percent of its quota, beating out Marion County's 144.8 percent, Trumbull County's 136.4 percent, Cuyahoga County's 135.5 percent, and Mahoning and Stark Counties' 128 percent. The bond drive was not done yet—with the competition among counties, Summit brought in $47,084,874 or 178 percent of its quota by the end of October 1943. South and East Akron led the way with contributions from rubber workers and plants.

In May 1942, *Beacon Journal* carrier boys passed the four million mark in the sale of 10¢ war stamps to help give Ohio the best weekly average in the country and second place in total sales behind Pennsylvania. The *Philadelphia Bulletin* had the idea to sell war stamps and had a head start, but the *Beacon Journal* and Ohio thought they would catch up soon after taking second place from the state of New York. Akron youths did more than sell war stamps. During Christmas break in 1943, five hundred Akron High School students earned extra money helping Uncle Sam deliver wartime holiday mail.

Goodyear Aircraft began in December 1939, just months after the Germans invaded Poland. The Glenn L. Martin Company had a contract to build B-26 Marauders, an all-metal bomber for the army. Martin contacted Goodyear about making some of the parts for them, and since Goodyear was a rubber company, it created Goodyear Aircraft as a subsidiary to build the parts for the metal planes. Thirty men who had experience in lighter-than-air flight were originally assigned to Goodyear Aircraft in 1939. Goodyear had built blimps, balloons, gas masks and other items in World War I but had largely produced very little afterward, since the thinking was there would be no more wars.

Goodyear Aircraft built more than half of the wheels and brakes for the American fighting planes of World War II. Goodyear came into the wheel- and brake-building business somewhat by chance. Akron Airport and hundreds of other airports across the country were originally not paved and were nothing more than cow pastures. Goodyear realized that planes landing in dirt and mud performed much better with a low-pressure tire than the high-pressure tires that were being used. There was not much money in planes at the time; all wheel and brake manufacturers focused on automobiles and refused to make wheels and brakes for Goodyear's new airplane tire. As a result, Goodyear decided to start making airplane wheels and brakes itself, which led to it becoming one of the biggest manufacturers of plane wheels and brakes in the war. In 1940, Goodyear Aircraft started its own department dedicated to tires, wheels and brakes for airplanes and was quickly turning out a million dollars a month worth of products in this department alone.

Airplane contracts kept rolling in to Goodyear Aircraft, and at the end of 1940, it had grown from 30 employees to 860. More plane orders came in 1941, which led to the construction of Goodyear Plants B and C to handle the increased production. During the war, Goodyear Aircraft made parts for Martin bombers and flying boats; Lockheed Lightnings and Venturas; Curtis Warhawks; Northrop Black Widows; Grumman Hellcats, Tigercats and torpedo bombers; Consolidated Coronados and Liberator bombers; and helicopters. In total, Goodyear Aircraft contributed significant parts to almost 17,000 aircraft. That does not count the countless planes that Goodyear Aircraft provided with wheels and brakes. By the end of 1941, Goodyear Aircraft employed 3,500 workers. By July 1942, Goodyear Aircraft was hiring 6,000 a month. Goodyear Aircraft had 31,000 on its payroll by the end of 1942, including 12,000 women. Payroll was over 32,000 people in 1943 and over $7 million in wages. In two years, Goodyear Aircraft went

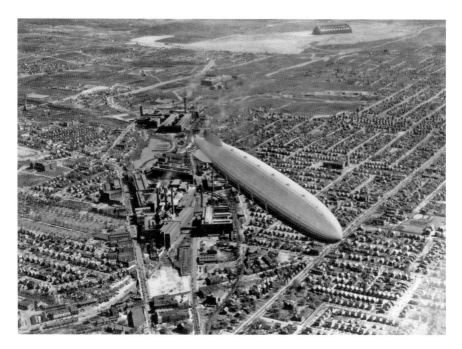

The USS *Akron* flies above Goodyear and rural East Akron in 1931; there was no Rubber Bowl, Soapbox Derby or Goodyear Aircraft yet. *Akron–Summit County Public Library, Shorty Fulton Collection.*

from 17 engineers to 1,500. June 1943 saw 1,200 Akron high school students go to work for Goodyear Aircraft as their summer job.

The B-26 Marauders proved durable. In a nine-month period from the summer of 1943 until the spring of 1944, the Marauders flew 16,800 missions with the loss of only forty-three planes. Marauders in the Pacific in the early days had no fighter cover and took out ninety-six Japanese Zeroes while only losing six planes. The Marauders had no spare parts for eighteen months, and by the end of that time, thirty of the fifty-three sent to the Pacific were still in service.

Thousands of Akron war workers celebrated on June 15, 1944, when they heard that B-29 Superfortresses had bombed Japan. Akron made over eighty parts for the B-29, and Akron companies produced other parts throughout the United States, including the five-hundred-pound bombs. The B-29 featured Akron-made tires, fired at the enemy with Akron-made cannons and used self-sealing fuel tanks produced in Akron. Other items produced in Akron for the B-29 include electrically heated flying suits, high-altitude oxygen masks, the giant midsection of the plane, deicers to keep the wings

from icing up and the planes from crashing, and of course life vests and rafts. All the major rubber companies produced parts for the B-29. Rivnuts used on the B-29 were patented by Goodrich and originally used to install deicers. Rivnuts were used by the thousands to put the bodies of planes together faster throughout the plane-building industry.

The B-29 Superfortress was designed for long-range bombing, which meant it was built for the Pacific theater of war. The B-17 Flying Fortress had enough range for the European theater, but the Japanese mainland was not in range. Allied forces were continually trying to capture islands closer to Japan to get their bombers within range of the Japanese mainland. A bloody price was paid for the islands of Iwo Jima and Okinawa. The American strategy in the Pacific featured the B-29 and the relentless bombing of Japan. In 1945, the Superfortresses starting delivering the utter destruction President Truman promised Japan if it did not surrender. Reports rolled in throughout the summer of 1945 with raids of five hundred, eight hundred, nine hundred and even one thousand Superfortresses bombing the Japanese mainland in one raid. In July alone, there were seven raids with five hundred or more B-29s attacking Japan. It became clear in the summer of 1945 that America intended to make Japan surrender with devastating airpower. When the constant conventional and fire bombings from B-29s did not convince Japan to surrender, America used the B-29s to drop two nuclear bombs on the cities of Hiroshima and Nagasaki.

B.F. Goodrich also had over four hundred employees secretly working on the equipment and parts for the atomic bomb. Two scientists from nearby Wooster, Ohio, Dr. Arthur Compton and his brother Karl, the head of MIT, helped develop the atomic bomb. Goodyear developed a rubber belt that Karl Compton used at MIT to conduct research and development of the atomic bomb. Other area businesses involved in what came to be known as the Manhattan Project were Burt Manufacturing Company, Akron Ornamental Iron Works, Firestone Tire & Rubber Company, U.S. Stoneware Company in Tallmadge and Chamberlain Engineering in Ravenna.

The first Corsair built by Goodyear Aircraft was completed in February 1943 and first saw action with the marines operating off Guadalcanal in May 1943. The navy also used the Corsair, and the new fighter plane earned praise from both Admiral John McCain and Admiral Chester Nimitz. Production went from 5 planes in March 1943 to 86 a month in October 1943, and the navy wanted more. Goodyear produced 175 planes in December 1943 to end the year. By the anniversary of the Corsair's first test flight in February 1944, Goodyear Aircraft had gone from 1 plane

to 1,000. By August 1944, 2,000 Corsairs rolled off the lines, and in two years, Goodyear Aircraft had made 3,000 Corsair fighters. By the time the Japanese surrendered, Goodyear Aircraft had sent over 4,000 Corsairs from their test flights over Akron to the war zones of Europe and the Pacific. In addition to the American military, Corsairs were sold to Britain, Australia and Newfoundland. In October 1943, the Corsair statistics in combat were impressive. One marine squadron took out 68 Japanese Zeroes in two months while only losing 3 planes. Lieutenant Commander John Blackburn led VF-17—known as the "Jolly Rogers" or "Blackburn's Irregulars"—a unit that shot down 60 Zeroes in five days and 154 in seventy-six days of combat. One group of 75 marine pilots used the Corsair fighter to shoot down 5 Zeroes or more for every man in the outfit.

According to Goodyear historian Hugh Allen, by the end of the war, the Corsairs packed as much punch as a destroyer with eight five-inch rockets, bombs, a twenty-millimeter cannon and fifty-caliber machine guns. As the war in the Pacific increased in intensity, the Corsair saved lives. One squadron alone took out 40 kamikaze planes. During the month-long Battle of Okinawa, Corsair fighters took out 209 Japanese planes while only losing 4—a ratio of 50 enemy planes shot down for every Corsair. As the air war against Japan intensified, the "Death Rattler" marine squadron chalked up 90 enemy planes in thirty days, including a famous tally of 24 Japanese planes in twenty-five minutes in April 1945. The Death Rattlers used the Corsairs to shoot down 124 planes while losing none. The Japanese Zeros were clearly outmatched by the Corsair, which the Japanese pilots accurately called "Whistling Death" for the sound it made as it was knocking them out of the sky. In February 1945, the Corsairs first flew over Tokyo as part of a 1,200-plane attack force. Goodyear Aircraft's Corsair fighters, combined with parts for the B-29 bombers and Akron's role in production of the atomic bomb, helped speed the end of the war in the most devastating fashion. The air war saved America from another mainland invasion and possibly hundreds of thousands of lives.

Firestone Tire & Rubber Company made 80 percent of the Bofors anti-aircraft guns used during the war, with its 25,000th rolling off the production lines in April 1944. The million-dollar Bofors plant was started in April 1941 and took just three months to complete. One thousand additional men and women were hired to help produce the weapons alongside around eight hundred current employees. Hower Vocational School worked around the clock training people to make the weapons. In 1943, Akron produced more anti-aircraft guns than anywhere else in the United States and the rest of

the Allied nations combined. Firestone made quick improvements in how the guns were built to go from 476 a month to a record-high 1,508 a month. On New Year's Day, 1943, at the stroke of midnight, men and women from Firestone were pictured by the *Beacon Journal* ringing in the New Year by building the Bofors guns to help win the war. The weapons were produced for both the army and navy and proved valuable to Liberty merchant ships in fending off airplane attacks. The 25,000 guns, if fired together, could send six million pounds of steel and three million shells in the air in one minute. Prior to D-day, Bofors guns saw significant action in the defense of England, North Africa, Anzio, Guadalcanal and Tarawa. The Bofors guns were constantly loaded off production lines onto converted trucks that used to carry cars to dealerships. Their first stop was the Lake Erie Ordnance Depot attached to Camp Perry. There, a group of men and women trained to test the weapons fired them over the skies and waters of Lake Erie. The big Bofors guns left Lake Erie Depot on trains and headed to the frontlines, first seeing action in North Africa.

The year 1944 was a good one for Firestone, with record sales of $651 million beating its previous record from 1943 of $545 million. It looked like 1945 would be another good year for the rubber industry, with the war production board ordering 28.8 million tires in December 1944 in anticipation of further delays in victory due to the German surprise offensive that month. In total, Akron received over a half a billion dollars' worth of war orders from June 1, 1940, through October 1944.

America's first barrage balloon was tested in Akron at Wingfoot Lake in February 1940. Goodyear, which was conducting the tests on the balloons, hoped to make them more effective than the ones being used in Europe. In 1940, Goodyear built the barrage balloons as a defensive measure to hamper the effectiveness of enemy planes attacking American cities. By June 1941, under the Lend-Lease agreement, female workers had taken over the Goodyear gymnasium building to build the "clumsy sky monster capable of going up 15,000 feet to ride the winds of defense of some city in the path of the blitzkrieg," according to the *Akron Beacon Journal*. In 1942, both Firestone and General Tire were producing barrage balloons alongside Goodyear, including small ones used to protect ships. Many of the balloon room workers were women who had recently graduated from Akron high schools, and the average age was under twenty-one. Invasion after invasion, barrage balloons were used to protect Allied shipping and transports. On D-day, barrage balloons filled the skies around Normandy, protecting Allied men and supplies.

After the war, many Americans may have ended up wearing barrage balloons—the number-one buyer of these defense weapons was raincoat makers, who could turn the balloons' waterproof skin into a new defense against the raindrops of Mother Nature.

James Albert Merrill was honored by President Roosevelt at the White House on December 10, 1942, for improvements he made in the self-sealing fuel tank at Goodyear that saved the lives of thousands of fliers. Gasoline makes rubber swell, and researchers developed a rubber lining in the gas tanks for planes that, when hit by bullets, would essentially use the gasoline leak to expand the rubber lining and plug the leak. This improvement of self-sealing tanks, which were first invented in World War I, allowed American planes to take a beating compared with Japanese planes that had no such protection. Merrill helped improve the self-sealing tanks by creating a thin barrier that kept aromatic gasoline from destroying the tanks.

Ensign Clement L. Burkley Jr. grew up at 1857 Goodyear Boulevard, where his parents lived after marrying at St. Bernard's Church on November 27, 1918. The son of a Goodyear chemist and inventor, he was a 1940 East High School grad and honor student who attended the University of Akron before the war. He was a torpedo bomber pilot on an aircraft carrier who was killed in action at twenty-one on June 1, 1943. Clement's younger brother Tom was inducted into the National Inventors Hall of Fame, and his dad received the Paul W. Litchfield Award of Merit for his work developing ice-gripping tires during World War II; he also received a citation from the government.

WAR TIME

In 1942, President Roosevelt announced the need to conserve electricity to power defense production, and Congress passed a bill to help do just that. On Monday, February 9, 1942, at 2:00 a.m., clocks across the United States moved ahead one hour, and they stayed there for the duration of the war. Ohio was on Central Standard Time until 1927, when the eastern half of Ohio switched to Eastern Standard Time. The western half of the state was still on Central time for nine years, causing quite a bit of confusion until the state legislature put all of Ohio on Eastern Standard Time in 1936.

War time was most popular in the cities and most hated among farmers. Parents also detested the fact that their kids had to get up and leave for

school in the dark. War time was called fast time, and Eastern Standard Time was referred to as slow time.

In early 1943, the Ohio legislature and Governor John Bricker followed states like Michigan and Georgia in passing a bill switching back to Eastern Standard Time or Central War Time. Cities across Ohio, including Akron, refused. The Ohio attorney general had to force government buildings in Akron and across Ohio under state authority to revert back to Eastern time. The clerk of municipal courts set the clocks back as ordered but opened and close the doors an hour later to keep war time hours. Employees of the county courthouse were told to report to work as usual at 8:00 a.m. war time, while the county simply set clocks back an hour to comply with the law. State liquor stores, board of elections and employment offices were also forced to switch to Eastern time. The city of Akron continued to operate on war time, as did buses, trains, airplanes and factories. Eastern Standard Time earned another nickname, "Bricker time," while war time was called "Roosevelt time." The *Beacon Journal* summed up the confusion best on February 20, 1943, with the simple question "What time ya got?"

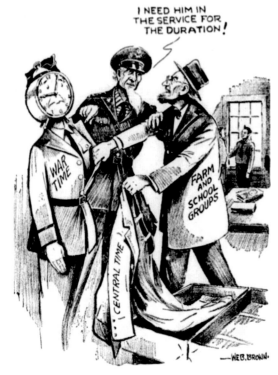

School and farm groups push to get rid of war time. *Reprinted with permission of the* Akron Beacon Journal *and Ohio.com.*

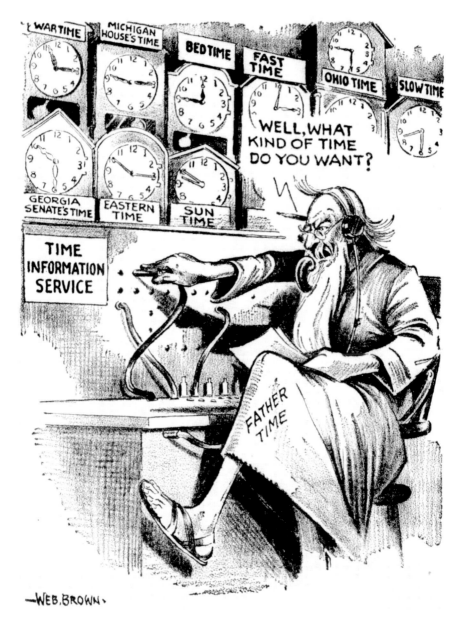

Father time works the switchboard. *Reprinted with permission of the* Akron Beacon Journal *and Ohio.com.*

BOB HOPE, JACKIE COOGAN, ROY ROGERS AND THE *MEMPHIS BELLE*

While Clark Gable threw caution to the wind, donned a uniform and joined the fight, other celebrities pitched into the war effort by boosting morale for the soldiers overseas and for the people toiling at home as the demands of total war called for labor and supplies from all corners of the nation. Although none of these celebrities were native Akronites, they all stopped in the Rubber City to recognize and praise its importance to sustaining the struggle.

On September 24, 1944, Bob Hope returned to the state he grew up in and came to Akron to speak to a crowd of twenty-two thousand at a memorial service in the Rubber Bowl. The field seated Gold Star Mothers from all wars, including the mothers of the nearly six hundred men and women in Summit County who had been killed so far. During his speech, Bob Hope said:

> *Ladies and gentlemen I wish the Akron Rubber Bowl were big enough so that every American could have been here to stand with us for that one silent minute of tribute to your sons and daughters. Being a part of this memorial service gives you an idea what it must have been like that day at Gettysburg. On that day a man made a short speech, "Let us here resolve that these honored dead shall not have died in vain."*
>
> *You may have heard, folks, that I spent the summer with our men all over the Pacific, and I want to tell you that this bowl is a picture of the kind of America those kids dream about. The name of this city is Akron, it would have done their fighting hearts good, even the ones who've never been to Akron, because believe me they all know what Akron means to the fighting machine. Whenever a B-17 sets down once again Akron's big tires have come through. When a truck bounces over roads ruined by shell fire, Akron's trademark is written on that ground. Akron is in every battle, on the ground and in the sky. You people here tonight have mixed your sweat with G.I. sweat in every battle since Pearl Harbor. A laugh shortens the day for a fighting man, but your work shortens the war. The reason I'm not wearing a hat tonight is that long ago I took it off to you people of Akron for doing your best to shorten this war.*
>
> *If you talk long enough with a man you find out that nobody in this world hates war quite as much as the man who has to fight it. The physical things that he expects to find when he comes back...like a decent*

job with an opportunity to build a future where kids won't forever be running off to fight just one more war.

Among you as your guests are Gold Star Mothers from your local chapter, because this day is National Gold Star Mother's Day. These are mothers who so painfully have learned what a costly thing freedom is. In paying our tribute to these mothers, let's tell them how thankful we are to them. Thank you.

In 1898, William McKinley became the first president to visit Akron when he spoke at Grace Park. The whole town turned out to see the president. In 1924, it was nine-year-old Jackie Coogan who was at Grace Park thrilling a crowd of five thousand kids. Jackie Coogan was a child film star, appearing in *The Kid* with Charlie Chaplin in 1921 and countless movies in the years to follow, including *Oliver Twist*. Jackie Coogan Sr. brought his famous son to town on his charity tour to raise money for needy children of the Near East. In 1929, Jackie was back, and the kid who got his start in the silent-film era thought that talking pictures were the films of the future. "I don't know what my next picture will be but we have been thinking that *Huckleberry Finn* might be made again. I think I would like to play in it." Coogan attended the *Akron Beacon Journal* Spelling Bee at Central High School and delighted

the crowd as kids competed to win the free trip to Washington, D.C., to meet President Hoover. Jackie's main job while he was in town was as the headliner at the Palace Theatre. Coogan would return to Akron as World War II erupted in Europe. In November 1939, Jackie was in town to act in a play at the Colonial Theatre. All grown up at twenty-five, he spoke of the divorce he was getting from Betty Grable and his new girl dancer Harriet Haddon while staying at the Mayflower Hotel.

As a flight officer, Jackie Coogan came to town to headline the flying competition of model plane builders at Sheppard Field on September 24, 1944, the same day Bob Hope was speaking at the Rubber Bowl. Coogan had made headlines earlier in the year when he became the first glider pilot to

Bob Hope *(right)* and Jackie Coogan *(left)* are in Akron on September 24, 1944. *Reprinted with permission of the* Akron Beacon Journal *and* Ohio.com.

land behind Japanese lines in Burma. "If you think the natives were surprised when our gliders landed, you should have seen them when we opened up the mouth of one and drove out a jeep. Two of them must have thought I was a god because they followed me everywhere and that night even made me a bed out of banana leaves." After the war, Jackie became known to another generation of Americans as he continued acting, including his well-known role as Uncle Fester in *The Addams Family*.

On Monday, July 5, 1943, Captain Robert Morgan and his crew flew the famous B-17 Flying Fortress *Memphis Belle* into Akron Airport. The *Memphis Belle*'s crew was the first to make it through its bombing missions in Europe with plane and crew intact when it returned to the United States. The *Akron Beacon Journal* reported: "As the nine members of the *Belle*'s crew visit Akron war plants tomorrow, they will meet the men and women who build the fuel cells, the life rafts and jackets, the deicers, the tires and many other Akron products which go into the construction and operation of every fighting plane." The *Memphis Belle*'s crew spent all day touring rubber factories, starting with

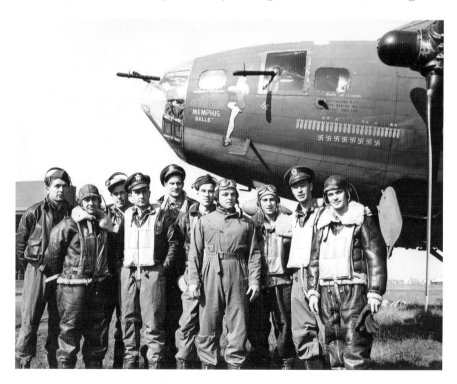

The crew of the B-17 *Memphis Belle* visits Akron Airport in July 1943. *Reprinted with permission of the* Akron Beacon Journal *and Ohio.com.*

The singing cowboy Roy Rogers talks with a tire worker at Goodyear Tire & Rubber Company. *Goodyear Tire & Rubber Company Records, Archival Services, the University of Akron, Akron, Ohio.*

Roy Rogers mingles with a group of women during a visit to Goodyear factories in 1945. *Goodyear Tire & Rubber Company Records, Archival Services, the University of Akron, Akron, Ohio.*

Seiberling, Firestone and Goodrich before heading for lunch at the Mayflower Hotel. The men were given a life raft by B.F. Goodrich and in the afternoon toured Goodyear and General Tire & Rubber Company. Their famous plane was on display at the airport for two days as the men gave speeches and signed autographs to huge crowds all over Akron. Their mighty Flying Fortress left town on Wednesday, July 7, for their next stop in Cleveland.

Cincinnati native Roy Rogers came to Akron and visited Goodyear on April 20, 1945, to tour the factories, see the products that were advertised on his show and thank war workers. He spent the day talking with executives and war workers and signing countless autographs.

THE RUBBER BOWL AND AKRON AIRPORT

On Sunday, August 8, 1943, at 7:00 p.m., Akron Civil Defense sprang into action as Flying Fortress bombers from Columbus raided the Akron Rubber Bowl. Admission was free for the twenty thousand spectators, and as the bombers flew over the Rubber Bowl, the neighborhood block set up on the football field reacted to the air raid sirens. Explosions were set off using mines to simulate the attack, and Civil Defense went about rescuing civilians trapped inside the burning city block. "When a schoolhouse being used as a first aid post partially collapses and is set afire, the screams of the trapped children and the shouted orders of the rescuers will echo through the Bowl," reported the *Akron Beacon Journal*. The entire air raid was narrated from the Rubber Bowl press box. Afterward, Major General Ulysses S. Grant III, the grandson of the Civil War general and former U.S. president, gave out Ohio's first citation for meritorious and outstanding service to the Akron Civil Defense organization.

On Memorial Day, 1945, the Firestone Tire & Rubber Company sponsored the invasion of Akron to raise money for the Seventh War Loan Drive—150,000 men, women and children surrounded Akron Airport to watch army paratroopers fall out of the sky to capture the field with support from glider troops. One featured paratrooper was Akronite John Allen "Bud" Seiler Jr., whose father emigrated from Germany in 1891 and owned twenty-two meat markets called Portage Markets before the Great Depression. After the war, Bud Seiler, a St. Vincent High grad, owned several Start and Sparkle markets, including the Highland Square location.

Both before and during the war, Akron pilots flew their bombers and fighters to Akron on furloughs and training missions. On a weekly basis,

warplanes roared into Akron Airport. Some pilots who were headed for overseas duty but couldn't stop at the airport liked to fly over Akron on their way out to say goodbye. There were occasional crashes, as was common throughout the country. Lieutenant Claude Jackson flew into Akron with Lieutenant Ralph C. Shrigley of Rootstown and the rest of their bomber crew so they could see their families on October 3, 1942. Later that day, as family and friends said goodbye to the two local fliers, their bomber crashed shortly after takeoff when the motor failed. All seven men on board were killed, including twenty-three-year-old Shrigley, as his parents watched in horror. Jackson's father, a captain of the Akron Fire Department, also witnessed his son's death. The civil defense police aided the city police in blocking off the crash site, which thousands of locals attempted to visit, leaving both Arlington Street and Triplett Boulevard packed with vehicles all weekend. Jackson, a Buchtel High School grad, attended the University of Akron for two years before enlisting after Pearl Harbor. He had flown on a training mission to Akron once before in his bomber in June 1942. Claude had already survived a bomber crash on August 27, 1942, in Mulberry, Florida, that killed everyone else on board and two women at the house it crashed into. Claude was the lone survivor and had just recovered from his injuries. Ralph Shrigley was a draftee and was not a member of the bomber crew. He was invited along on the trip because, like Jackson, he was from the Akron area. Claude's parents lost their only son at the age of twenty-one.

On September 1, 1944, First Lieutenant R.J. Ruschell of Cuyahoga Falls was in town visiting his mother. He had just left Akron Airport to return to duty in Michigan when his P-40 Warhawk crashed in the backyard of Jack Carney on School Street in Cuyahoga Falls, leaving him with a broken jaw and nose after bailing out. Ruschell had made it through 108 combat missions in North Africa and the invasions of Sicily and Italy. On day one of the Sicily invasion, Ruschell was shot down by Nazi fighters and spent a day in the Mediterranean on an Akron-made life raft before being rescued.

Second Lieutenant Bruce Arthur Hutchins was a Central High grad and pilot of the Flying Fortress *Coral Princess*. The twenty-five-year-old was killed on July 12, 1944, on a mission in Germany. He left behind his wife, June Flanagan, who worked at Goodrich, and the Kent State grad was an only child. Bruce flew his bomber over Akron and dipped a farewell salute on the way overseas. He couldn't land at Akron Airport at the time due to haze. He had enlisted on December 30, 1941.

TOP SECRET: AKRON AND GENERAL PATTON FOOL THE NAZIS ON D-DAY

A picture marked top secret sits in an *Akron Beacon Journal* file. The picture shows two ordinary looking anti-aircraft guns sitting in a factory. They do not look all that impressive, but further research explains why these were top secret weapons. The Goodyear and Firestone rubber companies both made inflatable top secret decoy weapons for the military. Inflatable landing craft, tanks, planes, anti-aircraft guns and half-tracks could be easily deflated and moved to another area to confuse the enemy. Most famously, they were used to confuse the Germans before the D-day invasion, when General Patton commanded a fake army with inflatable weapons.

CASUALTIES ON THE HOME FRONT: THE AMERICAN THEATER

On February 4, 1941, Cadet Edward Hersman, a former athlete at South High School, was killed in a training plane accident in East St. Louis, Illinois. Two days later, Lieutenant John Eakin collided with another plane over Farmingdale, New York, and died at twenty-six. They were the first 2 men from the Akron area to die in the American theater. Altogether, 195 men—over 10 percent of the area men who died in the war—were killed in the American theater. Sixty of these deaths were from plane crashes and accidents on the home front. Every week throughout the war, American papers carried news of bomber, fighter and training plane crashes occurring across the country leading to a significant number of deaths. Other causes of deaths in the American theater were auto accidents, lightning, heart attacks, accidental shootings, drownings, suicides, train derailments, illness and other accidents. The first nine men from the Akron area to die during World War II were all killed in accidents in the American theater in 1941.

Even crazier, when the *Akron Beacon Journal* published its Memorial Day Honor Roll in 1944 of men from Summit, Stark, Portage, Wayne, Holmes, Medina and Ashland Counties who had died so far in the war, the American theater had the most deaths: 155 men had been killed in the European theater, 129 men had been killed in the Pacific and 53 were killed at sea. The American theater had 173 confirmed deaths at the time. When the *Beacon* published its final honor roll on December 2, 1945, for its

seven-county coverage area, 300 names were listed as having died in the American theater.

Lieutenant Colonel Horace Groom, a doctor from Akron who went off to service in the fall of 1940, had this to say about the Louisiana peacetime maneuvers he participated in during August and September 1941: "There were fatalities in the maneuvers too—94 of them—but with more than 350,000 men scooting over the countryside both at day and during the pitch black of dark nights, the number was not considered excessive." The government did not seem to bat an eye when 94 Americans met death during the ten-week training exercise as they prepared for war.

On April 2, 1943, the army announced that it had set a new safety record in the first nine months of 1942 despite weekly reports of planes crashes. The army flew more miles in 1942 than in the entire decade of the 1930s: in the first nine months, the army flew 1.5 billion miles, equivalent to 60,000 times around the earth and a 135-percent increase over the nine-year period from 1930 through 1939.

Lieutenant Hugh Francis O'Neil was the son of General Tire & Rubber Company founder William Francis O'Neil and the grandson of Michael O'Neil, the founder of O'Neil's Department Store. He was also another area victim of the American theater. Hugh grew up at the Tudor mansion at 1290 West Exchange Street that is now a bed-and-breakfast. Hugh O'Neil also spent time with friends and classmates at the family farm on Bath Road. The family donated the farm to Summit County Metroparks, and it is now O'Neil's Woods. He graduated from his dad's alma mater, Holy Cross College in Massachusetts, before entering the Coast Guard. On an unexpected furlough home, Hugh married Jean Palmer, a 1934 St. Vincent High School grad and daughter of Palmer Furniture Company founder William Palmer, on Tuesday, June 9, 1942, at St. Vincent's Church.

Nine members of the O'Neil family had their pilot's wings in 1941, and they were often referred to as the "Flying O'Neils." In October 1941, Hugh finished air school in Pensacola, Florida, where he found quite a few British soldiers were training to serve in the Royal Air Force. Hugh chose to serve on an aircraft carrier upon graduation. He traveled home from Norfolk, Virginia, where he was stationed with the naval reserves, to witness the birth of his son, Rory Hugh O'Neil, on May 1, 1943. Two days later, while giving a talk at the YMCA, Hugh told the crowd that homesickness was worse than fighting the enemy. Battles end but homesickness is always there. He was on the aircraft carrier *Wasp* in 1942 but was checked into a hospital due to an injury. The *Wasp* was sunk in the Pacific on September 15, 1942. Hugh was

part of the "Flying Hellcats" squadron and flew eight combat missions. He was part of the attacks on Rabaul, Truk, Marcus, Saipan, Gilbert, Wake and Marshall Islands in November 1943, earning him a nomination for the Distinguished Flying Cross. Hugh returned to the States in March 1944 and took up a post as an aviation instructor in San Diego with his wife and son by his side.

Hugh O'Neil and Aviation Radioman John A. Sosnowski Jr. made headlines across the country in 1944. Sosnowski enlisted in the navy in October 1940 and was sent to Pearl Harbor in March 1941, where he was cited for bravery after manning an anti-aircraft gun throughout the entire attack. He was later transferred to a Goodyear navy blimp whose crew was called in to help rescue a pilot downed in a training accident in the Pacific Ocean one hundred miles off the California coast during a storm on May 12, 1944. A Catalina flying boat had landed in the rough water but could not get to the pilot—Lieutenant Hugh O'Neil. O'Neil lost consciousness, and Sosnowski, no stranger to bravery, jumped from the blimp into the Pacific to try and rescue him. Sosnowski reached the lifeboat but could not fight his way through the rough waves to get to O'Neil. The flying boat swung around and managed to pick up Lieutenant O'Neil, but Sosnowski's life was now in danger, as he was getting cold and could not swim to the flying boat. The pilot of his blimp came in low, threw him a line and towed him to the rescue plane. The plane, which was severely damaged by the waves, had to be abandoned, and everyone on board was picked up by a destroyer that was called to the scene.

The picture of John Sosnowski Jr's. leap from the navy blimp to rescue Lieutenant O'Neil appeared in papers across the country in May 1944. Sosnowski would recover from his injuries. He received a Navy and Marine Corps Medal for heroism. Lieutenant Hugh O'Neil died at the age of twenty-five in the training accident with his wife expecting their next child, Michael O'Neil. Hugh's son Michael would die at nineteen on Tallmadge Parkway, now Memorial Parkway, as he helped rescue a woman and two kids trapped on the caved road during a flash flood.

Several days after Hugh O'Neil crashed in the Pacific, another Akron man made headlines and almost died himself in a Pacific training accident off California. Captain Frank B. Baldwin was an aide to Paul Litchfield at Goodyear both before and after the war. Like Hugh O'Neil, Baldwin, a marine pilot, had served overseas flying combat missions. Baldwin may have left Goodyear and Akron but he was never far from home. The fighter pilot flew a Goodyear-made Corsair, and when that crashed

into the Pacific, his Goodyear-made life jacket kept him afloat. Baldwin inflated his Goodyear-made life raft and waited for help. The seas were too rough for a flying boat to land and rescue Baldwin. A destroyer was too far away, and in the cold water, Baldwin might not survive even on the life raft. The navy sent in a blimp, also made by Goodyear, to hoist Baldwin out of the water.

One of the most mysterious events of the war has an Akron connection. Lieutenant Ernest Cody, a 1938 graduate of the Naval Academy, and Ensign Charles Adams took off from Treasure Island, California, on a routine patrol flight in L-8, a navy blimp, on August 16, 1942. Later that morning, the blimp landed on the street in Daly City outside of San Francisco. The blimp was pilotless, and both Cody—whose wife, Helen Haddock, lived at 158 Portage Drive—and Adams were missing in action. Investigators found that the blimp originally landed on a beach and released a depth charge, then went aloft and landed in the city. The blimp had both parachutes and its life raft still on board. The last radio call from the men said they were going to investigate an oil slick. The navy told the family that a convoy or fisherman may have picked them up after they fell from the blimp. Akron lighter-than-air experts speculated that the blimp may have drifted through fog and low cloud cover and encountered a Japanese sub. Since their depth charges could not be used below five hundred feet, Akron experts speculated they were defenseless and taken prisoner. After missing for a year, the navy declared the men dead in 1943, and neither of them were ever found. The navy believed the men likely tried to fix something outside the blimp and both fell to their deaths. The ghost blimp was featured in May 1993 on the TV show *Unsolved Mysteries*.

Aviation Radioman Third Class William A. Humphrey, a Garfield High School grad, served for forty-three months in World War II. He was the sole survivor when an Akron-made blimp clipped a blimp hangar in Lakehurst, New Jersey, on a training flight, sending the blimp plummeting to the concrete runway 285 feet below. The ten other crew members were killed, including twenty-eight-year-old McCain Smith, the nephew of Vice Admiral John McCain Sr. Both John McCain Sr. and John McCain Jr. served in World War II, and they were the first father-son duo to reach the rank of admiral. They are the grandfather and father of former navy pilot, prisoner of war and 2008 presidential candidate Senator John McCain III. In the accident, William broke a vertebra, several ribs and a wrist.

Lieutenant Frank Trotter was one of three Goodyear pilots to go on active duty for the navy in January 1940. Trotter was partaking in a secret

Amelia Earhart and her husband George Putnam at the Mayflower Hotel in 1931. *Reprinted with permission of the* Akron Beacon Journal *and Ohio.com.*

experiment when two blimps collided over the Atlantic, killing him and eleven others. The blimps involved were the Goodyear *Ranger*, renamed L-2 when it joined the navy, and the Goodyear *Defender* (renamed G-2 in the navy), which was christened at the Cleveland Air Races on August 20, 1929, by Amelia Earhart.

GOODYEAR BLIMPS GO TO WAR

Before helicopters, there were blimps. Prior to the war, Goodyear blimps rescued people trapped in hurricanes, floods and the Everglades, as well as a daredevil trapped on Devil's Peak in Wyoming. During the war, Goodyear's lighter-than-air creations would float out of Akron to serve the war effort far and wide.

Goodyear's blimp history dates back to Paul W. Litchfield's trip to Paris in 1910, when he saw balloons and early planes being showcased and was convinced that aviation was the way of the future. Upon Litchfield's return from Paris, he started an aeronautics department at Goodyear, which was founded in 1898. Goodyear started building balloons to see how they worked and won the international balloon race in 1913. Goodyear's entry into the lighter-than-air field was at the right time—with World War I starting, Goodyear produced most of the lighter-than-air craft for the United States and some allies. It produced observation balloons to report enemy troop movements, artillery locations and approaching aircraft. Blimps, similarly to World War II, were used as spotters and protectors from submarines. Blimps could fly low, operate safely in fog and see deep into the water from the air to spot subs. There were no ships lost on either side of the Atlantic during World War I while a blimp was present.

In 1916, Goodyear built Wingfoot Lake, which still operates today. It built 1,000 observation and training balloons during the First World War and 100 non-rigid blimps. Goodyear continued blimp production on a much smaller scale after the war, producing a few blimps for the army and navy and building its own personal fleet, which carried four hundred thousand passengers across the U.S. skies between the wars. Despite its low volume of output, Goodyear's continued research and production of airships put it in a perfect position to produce them for the military during World War II. One of its important developments during the interwar years was advancements in mooring equipment, which allowed the blimps to travel anywhere without a hangar. Goodyear produced all 154 blimps used in World War II.

In October 1940, as the Akron National Guard was being called to service and the same fishbowl used to draw draft numbers in World War I was being used to kick off the nationwide peacetime draft in Washington, D.C., the navy ordered four K-type blimps from Goodyear. Goodyear began producing one blimp a month in September 1941 and had delivered its completed order two weeks prior to Pearl Harbor. The navy ordered two more blimps in June 1941, and in October 1941, Goodyear received an order for twenty-one

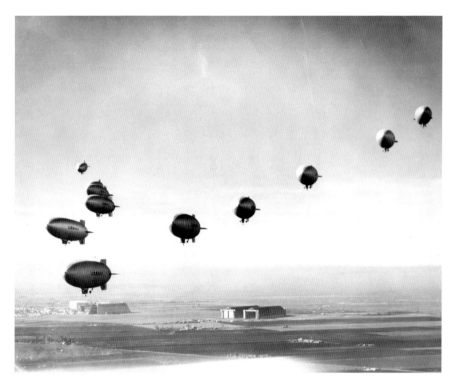

Goodyear navy blimps at Moffett Field in California. *Goodyear Tire & Rubber Company Records, Archival Services, the University of Akron, Akron, Ohio.*

more blimps. Increased hostilities in the Atlantic between American ships and Nazi U-boats were likely the reason for the significant increase in blimp orders in October 1941. The *Beacon Journal* in 1941 and historians since have accused President Roosevelt of being in an undeclared naval war in the fall of 1941 with the Germans. Early in the war, as German subs wreaked havoc, President Roosevelt asked Congress to increase the blimp fleet to forty-eight, and later Congress approved a fleet of up to two hundred blimps.

In order to protect American ships, which the Nazis were sinking from the Gulf of Mexico to the Caribbean and all the way up to Maine, the navy established blimp bases in Boston, Norfolk, Miami, Savannah, Galveston and New Orleans in addition to its base at Lakehurst, New Jersey. The West Coast saw bases in Los Angeles and Oregon in addition to Moffett Field to deal with any threat from Japanese subs. As blimps began dominating the American coast, the navy established bases in Brazil and other parts of South America to protect shipping in that region from the Nazi U-boats.

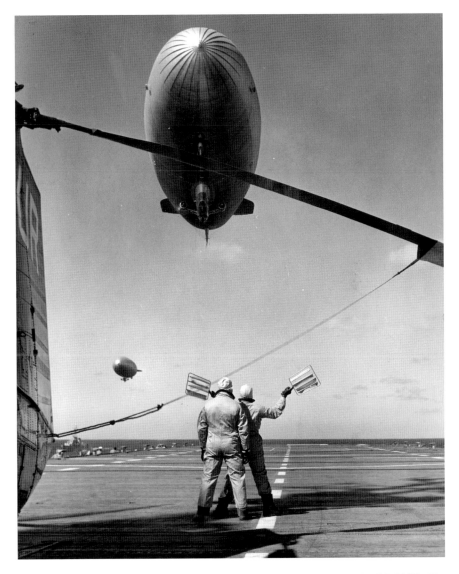

Two Goodyear navy blimps come in for a landing on an aircraft carrier during World War II. *Goodyear Tire & Rubber Company Records, Archival Services, the University of Akron, Akron, Ohio.*

Goodyear blimp pilots also headed off to war, including the pilots and the entire ground crew of the *Resolute* when it was sold to the navy. The navy ordered twenty-four more blimps in June 1942, and by June 1943, it ordered an additional sixty-two. Goodyear, which started out building one blimp a month, was now up to fourteen a month. Out of room for blimp building

in Akron, materials were shipped out to Moffett Field in California, where Goodyear employees helped build additional blimps. Goodyear eventually increased production to such a degree that it could build one blimp every other day. Goodyear increased its blimp-building space everywhere it could, even hauling back the bases it built for the Chicago and New York World's Fairs to Akron to be used in blimp production. At its peak, 2,500 men worked on producing blimps for Goodyear, and finding enough men to work on the blimps was increasingly difficult, as Goodyear lost much of its workforce to the draft.

America was not well prepared for World War II, and after Pearl Harbor, the navy desperately needed blimps. While Goodyear got busy increasing production, all five blimps of Goodyear's personal fleet—the *Reliance*, *Resolute*, *Ranger*, *Rainbow* and *Enterprise*—were sold to the navy and immediately got in the fight. These five blimps were armed with thirty-caliber guns and bombs, though the *Resolute* first saw action ten days after Pearl Harbor armed with only a hunting rifle. The blimps would later be armed with fifty-caliber machine guns.

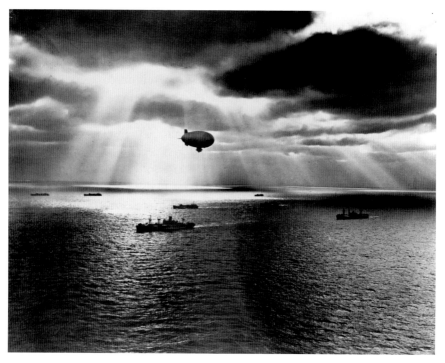

A Goodyear navy blimp guards a convoy in the Atlantic. *Goodyear Tire & Rubber Company Records, Archival Services, the University of Akron, Akron, Ohio.*

76

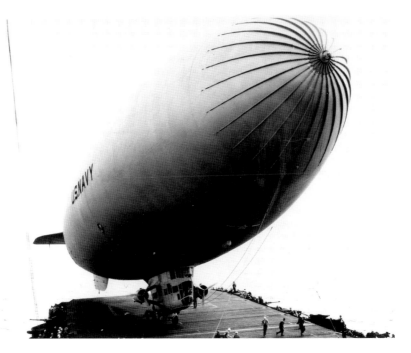

A Goodyear navy blimp lands on an aircraft carrier during World War II. *Goodyear Tire & Rubber Company Records, Archival Services, the University of Akron, Akron, Ohio.*

In December 1943, Commander Karl Lange, the highest-ranking former Goodyear blimp pilot, was made commander of the seventh coastal defense station in the country, which had just opened in Tillamook, Oregon, for Goodyear blimps to patrol more waters off the West Coast. In 1944, Lange's blimp squadrons made headlines for agreeing to report sightings of schools of fish along the Oregon and Washington coast while on patrol.

Blimps escorted 89,000 ships during World War II without the loss of a single ship. Blimps flew 35,600 missions in the Atlantic and 20,300 in the Pacific. Only one blimp was lost in action, when a Nazi sub and a blimp exchanged fire on July 18, 1943, in the Caribbean. Blimps guarded ships containing millions of troops and billions of dollars in supplies. The blimps, armed with guns and depth charges, were able to spot subs and make them dive to avoid being sunk. Nazi subs sank ships along the East Coast in early 1942, and as the Goodyear blimps chased them out of the area, the Nazis operated in the Gulf of Mexico in May 1942, sinking several ships. The disappearance of Nazi U-boats in American waters increased as Goodyear's production of the blimp increased.

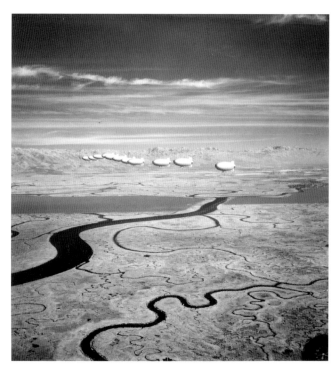

Goodyear navy blimps in San Francisco Bay. *Goodyear Tire & Rubber Company Records, Archival Services, the University of Akron, Akron, Ohio.*

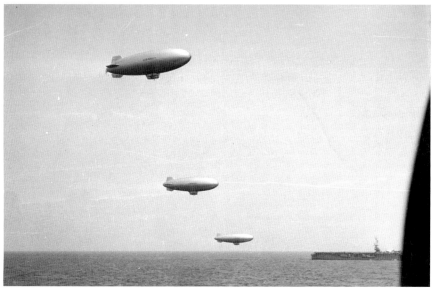

Three Goodyear navy blimps operate off an aircraft carrier. *Goodyear Tire & Rubber Company Records, Archival Services, the University of Akron, Akron, Ohio.*

The navy started the war with ten blimps. Six were stationed in North Africa and began operating there in June 1944. These were the first nonrigid airships to cross the Atlantic. During their operation, the squadron allowed no enemy subs to slip through the Straits of Gibraltar. It was kept secret that the Goodyear blimps had crossed the Atlantic and were operating in the Mediterranean. Radio broadcasts out of Nazi Germany indicated there were blimps in the area, and it was reported that at the Yalta Conference, one flew over President Roosevelt's convoy as protection. One of the more delightful stories at the end of the war reported that a Goodyear blimp escorted a Nazi U-boat to shore after it surrendered in the Atlantic.

Unfortunately for Goodyear, the war may have been the apex for blimps in the military. Blimps, which saw use in the navy throughout the 1950s, were eventually phased out of service. After the war, Goodyear tried to get the government to make a blimp that could fire a nuclear missile. President Ronald Reagan turned down the company's last attempt to get its blimps back in action—even after it catered to Reagan's idea of "Star Wars" and suggested making a blimp with sophisticated radar and defense systems capable of knocking cruise missiles out of the sky as they were fired from ships and subs.

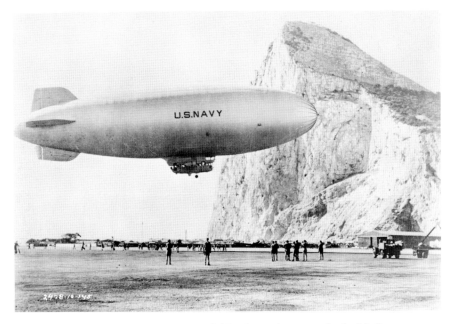

A Goodyear navy blimp passes the Rock of Gibraltar as it operates in the Mediterranean Sea during World War II. *Goodyear Tire & Rubber Company Records, Archival Services, the University of Akron, Akron, Ohio.*

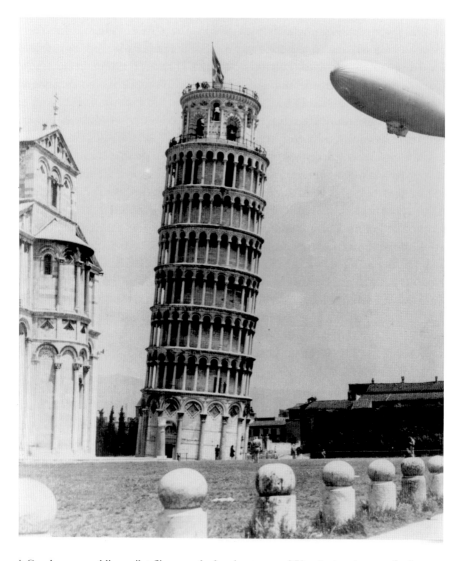

A Goodyear navy blimp pilot flies over the leaning tower of Pisa during the war. *Goodyear Tire & Rubber Company Records, Archival Services, the University of Akron, Akron, Ohio.*

You never know where life will take you. Clyde Shatter ran away from home at fourteen, lying about his age to join the marines in 1919. The young man saw overseas duty and was an orderly to the queen of Belgium on her American visit. He couldn't resist sending his parents a postcard while he was in Europe, and they were able to track their boy down and with help of their congressman get Clyde out of the marines. He went back to finish

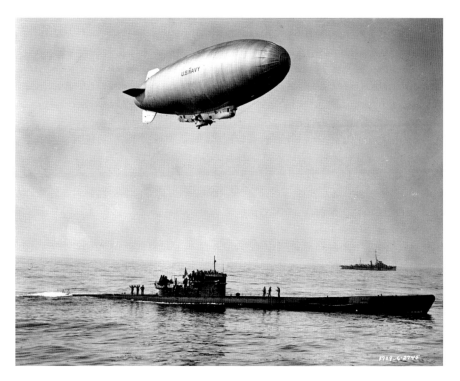

A Goodyear navy blimp flies over a captured Nazi sub. *Goodyear Tire & Rubber Company Records, Archival Services, the University of Akron, Akron, Ohio.*

high school and enjoyed writing. A teacher once gave him a B on a paper, writing that he could do better. Disagreeing with his teacher, he submitted the same essay to a statewide contest and won first prize. He went on to become a high school teacher himself and started a football team, telling the boys that he'd write a story about them for the paper every time they won a game. The team started winning, and Clyde turned in anonymous stories that were published word for word in the local paper. The paper took out an ad asking for the local ghost writer to contact it. Clyde did, and he left teaching after being offered the sports editor job at the *Ellwood City Ledger* in Pennsylvania. Clyde was always on the move, and by 1927, he was the radio editor for the *Akron Beacon Journal*. By the 1930s, he left the *Beacon* for a job in public relations at Goodyear with an interest in its lighter-than-air division touring the country in Goodyear blimps. The thirty-seven-year-old former marine joined the navy in 1942 and became Lieutenant Commander Clyde Schetter. He worked in the public relations field for the navy, too, at Moffett Field in California.

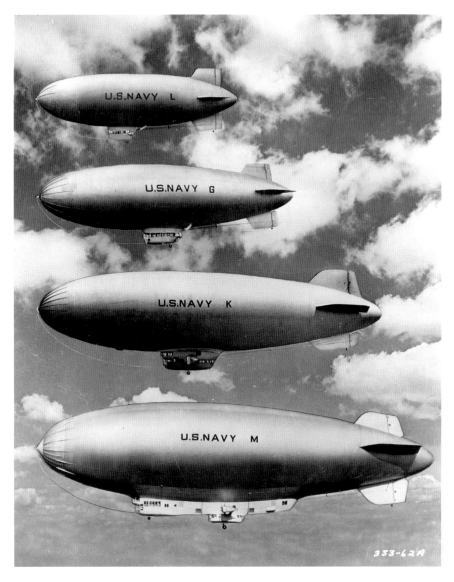

Above: The different classes of Goodyear navy blimps. *Goodyear Tire & Rubber Company Records, Archival Services, the University of Akron, Akron, Ohio.*

Opposite: A Goodyear navy blimp comes in for a landing on an aircraft carrier as warplanes operate in the background. *Goodyear Tire & Rubber Company Records, Archival Services, the University of Akron, Akron, Ohio.*

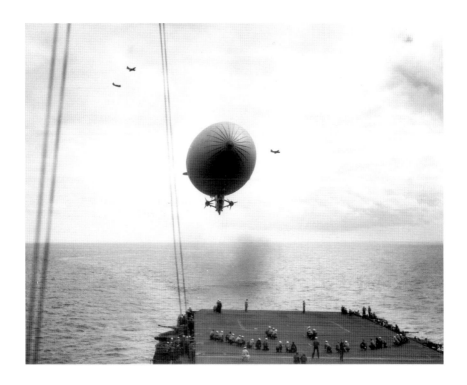

Akron's first world movie premiere occurred on Thursday, February 8, 1945, when Metro Goldwyn Mayer's film *This Man's Navy*, starring Wallace Beery, opened at Akron's Loew's Theatre. Many Akronites worked on the film about a blimp pilot played by Beery. Hugh Allen, Lieutenant Commander Clyde Schetter and former Akronite Lieutenant Commander F.A. Petri all worked as advisers on the film. Besides Wallace Beery, the film starred Tom Drake and Jan Clayton, who would later play the mom on the television show *Lassie*.

Wallace Beery made an appearance for both shows at the Loew's Theatre premiere to the delight of the six thousand Akronites who showed up to see the film. The midnight premiere was especially for war workers, and huge crowds waited in line to see the movie and outside of the Mayflower Hotel to catch a glimpse of Beery. He was a hit throughout Akron, and he kept adding stops to his busy schedule to tour more war plants to the delight of Akron's hard-working war workers. Like the *Memphis Belle* crew, he left Akron with a life raft, and he later sent back a photo of how he ended up using it with a note promising to visit Goodyear again. True to his word, he was back in Akron in December 1945, shooting hoops with teenagers at Goodyear Gymnasium.

Actor Wallace Beery's autographed photo of his donated life raft. *Reprinted with permission of the* Akron Beacon Journal *and Ohio.com.*

World War II blimps used by the navy were sold at the end of the war as the government cut back. Goodyear bought seven blimps back, and one was sold to a New York advertising firm. Millionaire Howard Hughes became the first individual to own a Goodyear blimp when he bought an L-type blimp used in the war to advertise his controversial film *The Outlaw*, starring Jane Russell. It was Russell's first film, and Hughes challenged the censors by having Russell wear less clothing than was permitted at the time. Hughes used the blimp to advertise the fact that the movie, which was kept off the screens by the censors for three years, would soon be in theaters. The *Outlaw* blimp was the first to promote a motion picture and the first permitted to have a neon sign placed on it. A World War II Goodyear blimp in 1946 cost $2,500 to $5,000, depending on the type.

LIFE RAFTS

In Laura Hillenbrand's World War II book *Unbroken*, which was later turned into a movie, Lieutenant Louis Zamperini's bomber plunges into the Pacific. The former Olympian makes it to a life raft on which he spends forty-seven days lost at sea before being picked up by the Japanese navy. The life raft that saved Zamperini's life was invented in Akron by James Frank Cooper.

J. Frank Cooper, a longtime Goodyear employee and inventor, was born in West Virginia. He was almost killed in the tragic 1928 National Balloon Race. Flying the balloon *City of Cleveland*, he was struck by lightning, knocked unconscious, plummeted 7,500 feet, hit the roof of a barn and then smashed into the ground, waking up to ask a Pennsylvania farmer what happened. Another Goodyear man, pilot Carl Wollam, bailed out with his parachute after trying to get Cooper out of the balloon. Wollam likely saved Cooper's life by slowing the descent of the balloon before bailing out. Two other balloonists were killed, and Cooper was burned and hurt badly enough that he stayed in the Greensburg, Pennsylvania Hospital for two months before returning to Akron. Cooper was the head of the Goodyear balloon room when it designed the *Explorer II*, which broke the altitude record on November 11, 1935, by reaching 73,000 feet. The previous record was set on January 30, 1934, by Russian balloonists who died when their balloon ripped after achieving an altitude of 72,200 feet. A Liberty ship was christened by Cooper's daughter Virginia Campbell in Los Angeles harbor on February 16, 1944, shortly after his death in 1943, to thank the man who saved the lives of so many fliers with his simple invention.

All the rubber companies produced life rafts that saved America's fighting men. Eddie Rickenbacker, the flying ace from Columbus, Ohio, shot down eighteen German planes and several balloons in the First World War. Rickenbacker would spend twenty-one days on a life raft in the Pacific after his plane went down during World War II. He later visited Goodyear to thank the workers in the life raft department for saving his life. The life raft even inspired a movie: Alfred Hitchcock made the Oscar-nominated movie *Lifeboat* in 1944 based on one of John Steinbeck's stories. These Akron creations also played a role in espionage, as spies often used life rafts to silently sneak ashore behind enemy lines throughout World War II to go about their work.

When Ensign George Gay Jr. crashed into the Pacific during the Battle of Midway, he wasn't floating in the ocean watching as American pilots sank three Japanese aircraft carriers like the 1976 movie portrays. George Gay

Akron *Beacon Journal* reporter Helen Waterhouse talks with Eddie Rickenbacker. *Akron–Summit County Public Library, Shorty Fulton Collection.*

watched and cheered the sinking of the enemy ships from an Akron-made life raft. In fact, the wounded pilot spent ten hours on that raft surrounded by Japanese warships as the battle raged all around him.

Sergeant James A. Morris Jr. of Cuyahoga Falls was in Hawaii as an aircraft mechanic attached to a bombardment group and later became a pilot. He

survived the attack at Pearl Harbor and went on to serve throughout the Pacific. Machinist Mate Bernard Latsch, who was a gunner on a Catalina rescue plane in the Pacific, told how a plane in his squadron pulled James "Red" Morris out of the water after he crash-landed and spent eight days on an Akron-made life raft. "I wish it could have been my plane," he said, "It would have been fun to pull 'Red' aboard and see his surprised look." Bernard Latsch was not only a classmate of Morris at Cuyahoga Falls High but he also lived down the street from Morris on Forest Glen Drive. Latsch's squadron was based in the Solomon Islands; he came home on furlough in early 1944 and was not eager to go back. He survived one bout with malaria and rescued six downed members of aircrews in eighteen months of overseas service: "I wish I could say there had been more rescued but out there with so much water when a plane is downed the chance of survival is not great." Some men were never found, and many died waiting to be rescued. It is hard to say for sure how long someone could survive on the ocean in a life raft, but one group of men made it eighty-three days. Drinking rainwater and eating fish, sharks and birds were the keys to survival.

Ensign Ray Rozuk was a South High School grad and basketball player killed on April 9, 1944, at twenty-four when his plane crashed in the sea off Attu. He was one of the unfortunate ones—the crew escaped to a life raft but was found frozen to death three days after the plane crashed.

Sergeant Henry Ellis Flowers was a 1940 East High grad and a radio gunner. He spent five days on a life raft with three others after their Mitchell bomber crashed off New Ireland in the Pacific. The men, who were escorted by sharks, drifted two hundred miles in the wrong direction. After a storm, they rigged a sail to the raft using a parachute and navigated toward what they thought was Bougainville. They drifted close to the Allied-held Emirau Island, nowhere near Bougainville, and used a mirror to reflect the sun for hours, with each member taking turns. Dusk was approaching when a ship caught their signal and rescued them. The men survived by eating raw fish and taking six sips of water a day.

Frank Davis, from Akron, had an interesting experience as his destroyer rescued three airmen from a life raft in the Pacific in 1945. The Goodyear-made raft was signed by the two Akron girls who made it, and he told the boys as he examined the names that one of the girls, Marie Brooks, was his classmate at Ellet High School.

Problems on the Home Front

Akron produced 65 percent of all heavy-duty military tires. In July 1944, a 30-percent lag in military tire production in Akron was blamed on absenteeism among workers. Studies showed an absentee rate of 2.5 percent was to be expected and was unavoidable. Akron and other areas of the country were averaging a 6-percent absentee rate and sometimes a rate as high as 10 percent. The top causes were inadequate transportation, not enough housing, shopping issues and lack of childcare facilities. Akronites would stand at bus stops unable to get to work because every bus that passed was packed. Even though there was a ride-sharing program, many cars that had room didn't participate. Gasoline and tires both being rationed cut down on the amount of driving by all Americans. The ride-sharing drivers often ended up on the bus when they didn't have enough gas to drive.

Coffee rationing began on November 30, 1942. Akron grocery stores were allowed to sell coffee until midnight on Saturday, November 21, but it could be hard to find. After midnight, sales were halted so the stores could restock and start rationing on November 30. Most grocery stores reported that long lines of Akronites were leaving empty-handed because the stores were out of coffee. The *Beacon Journal* was often critical of the government for announcing rationing in advance, which led to people buying up everything while they still could. Food rationing ended at midnight on Saturday, November 24, 1945, on all food items except sugar.

Women began working in record numbers, and there was not enough childcare available for them. The Goodyear policemen at the gate often found themselves watching a handful of children during their shifts, but this was far from ideal for both families and the policemen.

In January 1945, Akron welcomed the announcement of a 30-percent increase in military tire production over the previous month with production over 13 percent of the factories' goal. This still was not an adequate supply of tires; it just meant Akron was helping to reduce the shortage. The manpower shortage in 1945 was critical, with the government trying to determine if it would continue to defer men ages eighteen to twenty-nine who made military tires. The army and the navy desperately needed soldiers as the war in Europe took a turn during the Battle of the Bulge and action heated up in the Pacific. The military also desperately needed tires, and in a letter to Undersecretary of War Robert Patterson, the *Beacon Journal* made sure the government knew military tire production would be slowed significantly if a large number of experienced tire makers from Akron were drafted. Over

1,400 tire builders in the army, including many Akron men, were given furloughs home to help with the tire shortage, which General Eisenhower called his number-one need. Undersecretary Patterson replied to the *Beacon Journal* in early March 1945 thanking the paper for its advice and letting it know that tire builders ages eighteen to twenty-nine would be deferred despite the grave manpower shortage in the military.

A common myth about the war is that men in defense work could get a deferment. Men had to be absolutely essential to the defense industry to get a deferment, and many who were not considered essential were drafted throughout the war. This includes controversial draft groups like fathers and the young men of the Boy Scout Draft who were engaged in war work. Even though Undersecretary Patterson recommended the deferment of tire builders, he pointed out that the ultimate decision would be left to local draft boards. They would try to avoid drafting tire builders, but if they were short on their monthly quotas and the situation demanded it, the boards would draft even these essential workers. Akron factory jobs declined from 108,033 on June 1, 1944, to 98,019 by June 1, 1945—the main cause of this decline was men being drafted. The War Manpower Commission declared that there had been no cutbacks in war contracts in Akron; there were simply not enough men to fill the jobs.

As the manpower shortage raged on, more congressmen began questioning why so many athletes weren't in the service or the defense industry, and there was talk of the 1945 baseball season being cancelled. This prompted Cleveland Indians player and manager Lou Boudreau to take a war job in January 1945 in his hometown of Harvey, Illinois. Boudreau, the 1944 American League batting champion, was 4-F in the draft due to a rheumatic ankle. "I'm staying right on in war work if my profession is found not to be essential," Boudreau told reporters. Some athletes who were marked 4-F began to be drafted in early 1945, outraging some Americans, who pointed out that the army should not be drafting men declared not to be physically fit simply because they are athletes. The practice was eventually stopped, and 4-F athletes who did not meet standards were released from the military.

Also in January 1945, seven Akron members of the CIO, most of whom were members of the United Rubber Workers Union, left Akron to tour the European battlefronts. The union reps went to see conditions overseas and how badly tires were needed for the war effort. Strikes were a problem on the home front even before Pearl Harbor. America was supplying the fighting tools to Great Britain, Russia, China and other countries prior to

Pearl Harbor in an effort to keep out of the war by supplying those who were already fighting Germany. China was fighting Japan, but the October 23, 1941 *Beacon Journal* only mentions the need to stop strikes to defeat Hitler and Germany. In the first ten months of 1941, more than 3.5 million days of work had been lost due to strikes across the United States. Akronites, like other Americans, had suffered during the Great Depression, and with the war economy booming, patriotism and getting the wages and working conditions they deserved were in constant conflict throughout the war. At the end of 1940, America was adding five hundred thousand jobs a month, and 75 percent of production was defense goods for both the U.S. military and those fighting the Axis Powers. In this unprecedented era of jobs and prosperity, workers expected to be paid.

Strikes were controversial, as families wanted all the defense products necessary flowing to loved ones serving abroad. Anytime a strike occurred in Akron, soldiers from all over the world wrote letters to the editor expressing disappointment that their hometown factory workers were striking when they needed their support. Soldiers were not too sympathetic and were quick to point out that they weren't making much money in the army and were sacrificing a lot more than the folks at home. One of the most controversial strikes occurred at Goodyear on June 17, 1945. After the German surrender, American workers became more willing to strike across the country. The United Rubber Workers of America (URWA) had signed a no-strike pledge during the war, and the strike was not authorized by the national union. The Goodyear local, led by C.V. Wheeler, called the strike itself and ignored the URWA and the War Labor Board orders to return to work. Wheeler said he would gladly end the strike if the government seized the plants at Goodyear. Five hundred train cars sat loaded with Goodyear supplies, and as 16,000 workers sat idle, reports rolled in of 35,000 striking workers in Detroit and over 80,000 nationwide. By June 27, the nationwide strikes amounted to over 100,000 workers. After two weeks, the government threatened to take away deferments and any benefits it could think of from the 16,700 striking Goodyear employees. Things got worse on July 2, when Firestone workers doubled the number of strikers to 37,000 by walking off the job themselves. By the time Firestone joined them, Goodyear strikers had voted six times during their sixteen-day strike to defy the War Labor Board and refuse to return to work. By then, 272,000 tires had been lost to the strike, and things were getting ugly. Summit County draft boards blasted the War Labor Board for not doing its job and resented having to possibly draft more young men from Akron to try and coerce the men back to work. Strikers all over

the city were cashing in their war bonds in record numbers for money. On July 5, President Truman acted, and Captain H.K. Clark of the U.S. Navy read an executive order in the office of Goodyear president E.J. Thomas informing him that the navy would be seizing Goodyear for sixty days to return the striking factories back to war production. Striking workers were to report back to work on Friday, July 6, after a nineteen-day strike. After two weeks, Firestone strikers voted to returned to work on Monday, July 16. President Truman seemed to have his mind made up about the utter destruction of Japan, but all these strikes and work stoppages slowed defense production enough to increase Truman's willingness to use nuclear weapons. Acting secretary of war Robert Patterson said that without tires for planes, the military would have to scale back its aerial war and postpone other operations crucial to the overall strategic plan against Japan.

WAR STORIES

GENERAL JIMMY DOOLITTLE

On June 27, 1940, two days after the French surrendered to the Germans, honorary Akronite Major James Doolittle was called to duty at forty-five years old. In 1922, Lieutenant James Doolittle, a World War I flying ace, made headlines and became a national hero as the first man to fly across the country in less than twenty-four hours when he flew from Jacksonville to San Diego in twenty-one hours and nineteen minutes. Doolittle frequented Akron and Cleveland in the 1920s and 1930s, when he took part in national balloon and air races. His first visit to Akron occurred in 1924. Often flying into Shorty Fulton's Akron airport, Doolittle and Shorty became good friends. Doolittle was stationed at Wright Field in Dayton during most of the 1920s, and in October 1927, he flew up to Akron's Fulton Field to entertain a crowd of three thousand spectators with some of his famous stunt flying. Airmail routes were being developed at the time, and the federal government said Akron would be on a route as long as it had an airport. Fulton Field was then nothing more than farmland owned by Shorty Fulton.

Doolittle came back to Akron in June 1928 and announced at the University Club that he was leaving the army to be a consulting engineer for the Curtiss Airplane Manufacturing Company. In 1929, when he was working with the Guggenheim Foundation, Doolittle helped organize an aviation college to partner with the University of Akron's engineering

college. In 1930, Doolittle and Charles "Speed" Holman entertained Akronites on Navy Day, October 27, with Admiral William Moffett. B.F. Goodrich outfitted his plane with abrasion shoes in 1931, and he was back again in 1932 at a B.F. Goodrich conference. Doolittle was dropped off in Akron by fellow pilot James Haizlip, and after the conference, Akronites saw something they had never seen before: Doolittle got on a train to leave town. This was the same year that Doolittle won the Thompson Trophy at the Cleveland Air Races in front of a crowd of sixty-five thousand fans, including fifteen thousand from Akron. Doolittle was a beloved visitor to the area, often judging local model plane building contests at the airport.

Doolittle also came to town in February 1942 to help urge and praise Akron's war production efforts at a chamber of commerce dinner. Two months later, on April 18, Doolittle led his famous raid over Tokyo with a group of B-25 bombers. One of the pilots on the raid was Lieutenant William Bower from Ravenna. President Roosevelt awarded Doolittle the Congressional Medal of Honor upon his return. Doolittle, who attended

Left to right: A balloon pilot, an unidentified man, Jimmy Doolittle and Shorty Fulton at Shorty's house on Triplett Boulevard. *Akron–Summit County Public Library, Shorty Fulton Collection.*

Jimmy Doolittle naps at his friend Shorty Fulton's house while in town for a balloon race. *Akron–Summit County Public Library, Shorty Fulton Collection.*

the last Soapbox Derby before the war in August 1941, was the hero of the young racers he met that day. Akronites celebrated the raid by their famous friend, who referred to Akron as his second home.

Later that year, Doolittle was in a Flying Fortress over the Mediterranean as his staff headed to North Africa when Nazi planes attacked. Shorthanded because of the many officers traveling with Doolittle, the B-17 still fought off the attack. After the copilot was wounded, Doolittle gave him first aid and then took his place at the controls, helping Captain John Summers from Tennessee land the plane safely at its destination. The Nazi planes only made one pass, but the army later wondered if they would have attacked with more ferocity if they knew Doolittle was on board. Doolittle would operate out of North Africa and later led the Eighth Air Force at the end of the war. He also returned to the Pacific and was aboard the battleship *Missouri* for the Japanese surrender in 1945.

SHORTY FULTON

On August 30, 1942, Akronites packed the Rubber Bowl to watch the Cleveland Rams play the New York Giants football team. At halftime, Bain Ecarius Fulton was sworn in as a major in the Army Air Corps, and Akron said goodbye the man it affectionately called "Shorty." A longtime friend of Doolittle, Shorty Fulton used his connections to join up at the age of fifty.

Shorty Fulton was five foot five and came to Akron with his wife in 1916 to work for Goodyear. He had a passion for flying, and in 1924, he left Goodyear and took up residence in an old house with a barn on four lots on Old Massillon Road with his wife and three kids. He put out a sign that read "Fulton Field." Shorty learned to fly and repaired a wrecked plane to call his own. Akron's first airport was born on what used to be the Fulmer farm. It wasn't long before Shorty got the city to buy 870 acres to build an airport around his facility. A million dollars was spent leveling the ground, and Goodyear built its famous lighter-than-air hangar. In 1929, Continental Airlines offered flights from Akron to Cincinnati. Flights to Pittsburgh and Washington, D.C., were added in 1931. There were no paved runways until the WPA installed the first one in 1936; the fourth was installed in 1938. Four airlines operated out of Shorty's Akron Municipal Airport until the more modern Akron Canton Airport was built after the war. Shorty ran the airport, the Rubber Bowl and the Soapbox Derby prior to entering the military.

Fulton reported to officer training school in Miami Beach, Florida. Originally stationed stateside, he requested to be sent overseas. In 1943, Shorty was riding a camel and running airports along the Nile River for the army in Egypt. Two Akron men, Lamarr Pilkington and Harold Hobster Jr., had Shorty as their commanding officer. Pilkington wrote, "mother and dad, I've got the best news for you, I've discovered that my commanding officer here is none other than Akron's 'Shorty' Fulton. I had a long talk with him and he sure is a swell fellow." Shorty was always up to something. On July 4, 1943, Shorty wanted to celebrate, but no American band was in the area to play any patriotic music. Shorty called up the nearby British, who sent their band, and Shorty joked how he and the Redcoats celebrated the Fourth of July.

The Flying Fortress Shorty was a waist gunner on was one of twenty-two shot out of the sky on a mission over northern Germany to knock out enemy runways on April 7, 1945. Jimmy Doolittle sent word to Akron and Shorty's wife that he was missing in action. Shorty landed in a German labor

Above: The founder of Akron Airport, Shorty Fulton, sits shirtless atop a camel. Shorty operated airports along the Nile in Egypt during World War II. *Akron–Summit County Public Library, Shorty Fulton Collection.*

Opposite, top: Jimmy Doolittle *(left)* shakes hands with Shorty Fulton *(right)* before the war. *Reprinted with permission of the* Akron Beacon Journal *and Ohio.com.*

Opposite, bottom: Jimmy Doolittle *(left)* and Shorty Fulton *(right)* in Akron before the war. *Reprinted with permission of the* Akron Beacon Journal *and Ohio.com.*

camp and was immediately taken prisoner. Upon being captured, Shorty said, "they kicked the hell out of me." Upset over Allied bombing, German civilians gave Shorty a black eye that swelled shut and a broken rib and nose. "The guard tried to make me run; he wanted to make it appear that I was attempting to escape so he could shoot me." Shorty was taken to a dungeon, where he slept on the bare floor for five days with no blanket or medical care. He was then sent to another prison camp, marching up to fifteen miles a day with British Mosquito fighters occasionally strafing the prisoners and Allied planes bombing them three times. When the bombers were gone, as the prisoners walked through German towns, civilian mobs were a constant

Shorty Fulton in a German prison camp in 1945. *Reprinted with permission of the* Akron Beacon Journal *and Ohio.com.*

Shorty Fulton takes a stroll in a German prison camp. *Courtesy of Mike Fulton.*

Left to right: Friends for over fifty years, Shorty Fulton, Jimmy Doolittle and Herb Maxson. *Reprinted with permission of the* Akron Beacon Journal *and Ohio.com.*

threat. When Shorty arrived at the Barth Prison Camp, he saw something any Akronite might hope to see—"Was I glad to find about fifteen Akron boys there."

Shorty was liberated at Barth by the Russian army on May 1, 1945, and Doolittle sent word that he was safe and on his way home. He returned to his job managing the airport on October 16, 1945, while on leave from the army. He was formally discharged on January 5, 1946, which happened to be both his and his wife's birthday. Fulton was required to retire from his beloved airport in 1962 at the age of seventy. Doolittle continued to visit Shorty for decades after the war, taking part in the Soapbox Derby and coming to town for events honoring his longtime friend.

Dogs for Defense

War dogs date back to ancient Egypt, and at the start of World War II, Germany had fifty thousand trained dogs in its army. The Germans donated another ten thousand dogs to Japan. America considered dogs such a necessary part of war that over $3.5 billion was written into the war budget in 1943 for dog food alone. The British even flew captured German war dogs from France to Britain for interrogation. They hoped to gather military information by learning what the German dogs had been taught to do.

Clinton DeLos Barrett was born on June 22, 1900, in a Quaker colony in Leesburg, in Highland County, Ohio. He served in World War I and graduated in 1923 from Ohio State University's College of Veterinary Medicine. That same year, he came to work in Akron, and in 1927, with World War I vet Dr. Henry Noonan, he established Noonan & Barrett Animal Hospital at 490 East Cuyahoga Falls Avenue. On February 5, 1938, he married Gladys Burge. On January 21, 1941, Dr. Barrett, a captain in the army veterinary medical reserve corps, was called to service, and he went to Fort Robinson, Nebraska, for one year. He was in charge of the K9 Corps at Camp Robinson, supervising seventeen thousand war dogs at the largest dog center in the country. Dr. Barrett, who reached the rank of lieutenant colonel, also worked on cavalry horses during the war, even performing surgery on them at Camp Robinson. He was sent to the Pacific for six months toward the end of the war as commander veterinarian of the Western Pacific Command, stationed at Saipan. He oversaw the care of all animals on the Pacific Islands. Commenting on his dogs, Barrett said, "a scout dog was really nothing more than a well-trained bird dog, except that he was trained to hunt men." Dr. Barrett was pictured with a Japanese messenger dog captured by marines on Iwo Jima that he allowed to be brought back to the United States. Clinton Barrett ran and won election to the Akron School Board in 1951. He served for over twenty years, and a school was later named in his honor.

Through the Dogs for Defense program, Akronites could donate their dogs to Uncle Sam and send them to Dr. Barrett in Nebraska or to other dog training camps like Front Royal, Virginia. In the summer of 1943, Akron sent its fourth group of dogs to Camp Robinson. Karl Gravesmill of 85 Hall Street donated his German shepherd–collie; H.A. Minder of 148 Hawk Avenue sent his Doberman pinscher; Pearl Heideman of 1985 West Market Street donated her German shepherd; W.H. Phillips of 28 Fenton Avenue donated his collie; Margie McCloskey of 221 Gale Street donated

her German shepherd; and H.A. Wolfe of Copley sent his Belgian shepherd. In all, around thirty Akron-area dogs served in the war. War dogs discharged from the army with no owner were available for purchase. Lieutenant Colonel Harry Goslee of Columbus, Ohio, had two blue service stars in his window, one for him and one for his dalmatian, who was also in the service.

War dogs were not guaranteed to be returned home, but they often were. Most dogs didn't make the cut and were not sent overseas. Chips was a family dog donated by Edward Wren, a lawyer in Pleasantville, New York. Chips served three and a half years with the Third Infantry Division in North Africa, Sicily, Italy, France and Germany. A trained sentry dog, he was the only dog awarded the Silver Star; he left his post to attack an enemy machine gun nest in Italy, forcing the surrender of the machine gun crew. Chips returned to his family in New York after several weeks of detraining and got along well with Edward's kids, ages four to twelve, just fine. The army did tell Wren that it could not guarantee or be held responsible for Chips's actions—he was trained to be viscous at times.

War dogs were just like soldiers. They ate K rations, lost weight during lengthy invasions, got homesick and even suffered battle fatigue. After their service was up, just like soldiers, they received their discharge papers listing their accomplishments. On Iwo Jima, Kappy, a Doberman pinscher from Butte, Montana, received letters of commendation for saving the lives of marines. Butch, another Doberman in the Pacific, was given a medical discharge due to combat fatigue after being trapped on a beach for eight days with enemy fire constantly raining down on him and his trainer. "He goes crazy now when he hears gunfire. He's waiting for his medical discharge and will be sent home," stated a July 23, 1945 *Beacon Journal* article.

War dogs were used to carry messages, as guard dogs and scouts, and sometimes to detect land mines. Fritz, a Doberman pinscher, was a neighborhood problem dog, killing chickens and other farm animals, before he was given to Dogs for Defense by the president of Imperial Electric Company, John Hearty of 50 Orchard Street. Fritz returned after two years of service in which he and his handler were credited with forty-three enemy kills in the Pacific. Hearty planned to take back his hero dog if his detraining was successful.

War dog Duke Kinney, a dalmatian from 524 East Ford Avenue in Barberton, was honorably discharged in April 1944 after seeing action on Tarawa and Bougainville. Duke's family greeted him like any soldier at the Barberton train station, where twelve-year-old Russell Kinney was glad to have his pal back. In his fourteen months of service, Duke lost fifteen pounds.

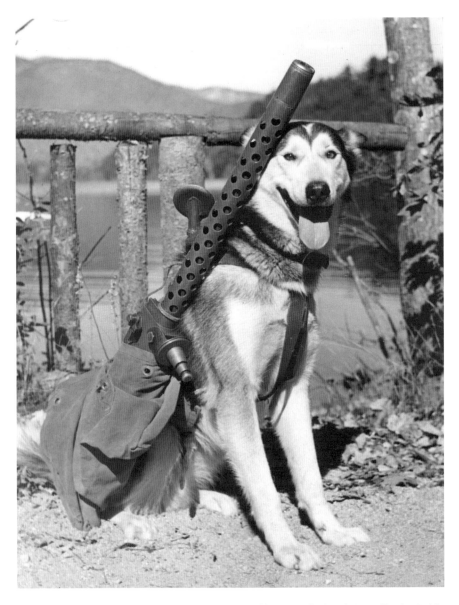

Muklug the war dog was trained to carry heavy machine guns during the war. *Reprinted with permission of the* Akron Beacon Journal *and Ohio.com.*

Rin Tin Tin, the famous dog found by Lee Duncan on the battlefields of France during World War I, visited Bowen School in Akron in the spring of 1930. A movie star, Rin Tin Tin was in town to appear at the Palace Theatre for the week and had plans to stop at the Summit County Children's Home

and Children's Hospital. Rin Tin Tin's grandson Rin Tin Tin III served in World War II, and Lee Duncan was back at it training war dogs at Camp Hahn in California.

At Wright Field in Dayton, some Akron men took part in a program at the aero medical laboratory that used grown chimpanzees to test the effects of high-altitude flight. The monkeys were discharged after the war and bought by the Columbus Zoological Society. The area where the monkeys were to be housed by the society was called Warrior's Rest.

CLARK GABLE

Clark Gable's wife, actress Carole Lombard, died when her plane crashed into Table Rock Mountain outside of Las Vegas on January 16, 1942. Lombard had gone to her home state of Indiana for the first bond rally of the war, and she helped sell $2.5 million in war bonds in one day in Indianapolis. Otto Winkler, Lombard's publicity agent, wanted to take a train back to Hollywood, but Carole preferred a plane. They flipped a coin, Lombard won, and they both lost their lives. Fifteen army airmen were also among the dead in the TWA crash.

Clark Gable at nineteen with his father, William Gable, in Akron. *Reprinted with permission of the* Akron Beacon Journal *and Ohio.com.*

His wife gone, the forty-one-year-old actor wanted to do his part in the war and didn't seem to care if it got him killed. He had no interest in selling bonds or giving speeches at rallies. Gable, one of the highest paid actors in Hollywood, entered the army at the rank of private and joined the air corps to be a gunner on August 13, 1942. Captain Gable went to England in April 1943, and by August, he was on a B-17 Flying Fortress participating in raids over Nazi Germany and France. In 1944, Major Gable was discharged from the army with his papers signed by fellow

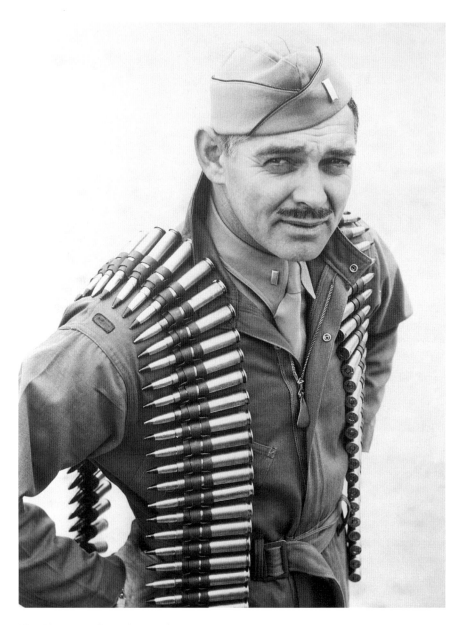

First Lieutenant Clark Gable, a former movie actor now an aerial gunner in the Army Air Corps, wears a double shoulder sling of fifty-caliber machine gun bullets while taking off on a practice firing mission at Tyndall Field in Panama City, Florida, on January 20, 1943. *Associated Press photograph.*

Ronald Reagan signs autographs in Akron in 1951. Captain Ronald Reagan signed Clark Gable's discharge papers. *Reprinted with permission of the* Akron Beacon Journal *and Ohio.com.*

actor and future president Captain Ronald Reagan. A Liberty ship was named for Carole Lombard in January 1944. It is said that Clark Gable got his acting start at the Colonial Theatre in Akron, where he spent a few years after dropping out of Edinburgh High School in Portage County.

WESLEY, RICHARD AND FRANKLIN SWENSON

Wesley Theodore Swenson was born on February 6, 1895, was a graduate of Highland Military School in Worcester, Massachusetts, and served on the Mexican border in 1916. Wesley married Edna Harbaugh, whose father started a well-known piano store in Akron at the turn of the century, at Trinity Lutheran Church on January 15, 1919. He was a businessman working for Pittsburgh Plate & Glass before opening a hardware store at Five

Points. He started making sandwiches with Edna and selling them out of his car to students at Buchtel High School when it opened in 1931. In 1934, Wesley opened his first Swenson's restaurant at the corner of Exchange and West Market Streets on the western border of Akron in Wallhaven. Wesley ended up doing very well, opening multiple locations—including one in Florida—before retiring.

His son Richard Swenson was born on New Year's Day, 1923, and went to West High School for one year before attending Kemper Military Academy in Boonville, Missouri, where he graduated in 1940. In April 1942, the Swensons threw a party for Lieutenant Richard Swenson at their country home on Shade Road in Ghent. At nineteen, he was one of the youngest officers in the country and was being called to duty during his sophomore year at Cornell University. Richard went overseas in 1943 and took part in the invasion of Sicily and the bloody fighting at Anzio with the paratroopers. He dropped into Holland in the fall of 1944 as part of Operation Market Garden and received severe head wounds that affected his speech temporarily, for which he was awarded the Purple Heart. Wesley and Edna hoped he would be sent home, but once he recovered, he went back into action. After serving twenty-nine months overseas and earning a Combat Infantry Badge, Richard Swenson came home on a ninety-day furlough and married army nurse Doris Taeckens from Flint, Michigan, on November 3, 1945, at Trinity Lutheran Church.

In one of the most interesting stories of the war, Richard Swenson was part of a group of soldiers who discovered Emperor Charlemagne's bones, crown, scepter, sword and cross, hidden by the Germans from Allied bombs throughout the war. Lieutenant Colonel Howard Jones, the chief property control officer in the Ninth Army, wrote "The articles date from 805 and were studded with more jewels than I imagined were in the world. And this Charlemagne must have been quite a man, for the crown was 10 times as heavy as our steel helmets."

Richard returned to finish his degree at Cornell in 1949 and served during the Korean War. He also graduated from the Army War College, the Command and General Staff College and the Armed Forces College. He taught at the Army Command and General Staff College and then did two tours of duty in Vietnam. When he returned, he was appointed the director of plans and operations of the Strategic Communications Command (STRATCOM) and rose to the rank of brigadier general after being nominated to that rank by President Richard Nixon in 1970. He retired in 1977 and passed away in 1988 at sixty-five.

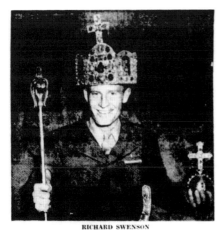

RICHARD SWENSON

TRIES CHARLEMAGNE'S CROWN

It's little wonder that First Lieut. Richard W. Swenson smiles as he tries on this crown and other royal vestments. The head ornament was given to Emperor Charlemagne by Pope Leo III. The sword, scepter and globe were unearthed along with the bones of the Frankish king in an air raid shelter near Siegen, Germany.

Left: Richard Swenson, the son of Swenson's Drive In founder Wesley Swenson, enjoys himself after months of fighting in Europe. *Reprinted with permission of the* Akron Beacon Journal *and Ohio.com.*

Right: Brigadier General Richard Swenson in 1970. *Reprinted with permission of the* Akron Beacon Journal *and Ohio.com.*

Richard's brother Franklin H. Swenson was born on September 9, 1920, attending Rankin School and graduating from Buchtel High School before attending Kemper Military School. He graduated from the Massachusetts Institute of Technology with a degree in engineering in 1943, and he served in the Army Anti-Aircraft Corps. Like Richard, during the war he met and married an army nurse; her name was Polly. He was running the Swenson's on East Cuyahoga Falls Avenue when his ten-month-old daughter became sick with influenza, which led to brain damage. Franklin didn't like not being able to help his daughter and enrolled in medical school, graduating from Case Western Reserve University in 1957. Polly, with five kids and a job as a night nurse supervisor at Akron Children's Hospital, managed to run the restaurant while Franklin became a doctor. After his graduation from medical school, Franklin left the Swenson's business behind him. He was the director of radiotherapy and nuclear medicine at Akron City Hospital until he retired in 1977. He passed away in Chippewa Falls, Wisconsin, in 1990.

Blanche Sigman

The only Akron woman killed by enemy fire was Lieutenant Blanche Sigman. Sigman was the chief nurse preparing for an operation at the evacuation hospital during the bloody fighting on the Anzio beachhead when a Nazi bomb killed her and twenty-six others on February 7, 1944. Ninety-six people were wounded in the attack. The patient Blanche was working on survived as the bomb killed those who were standing around the operating table. A Liberty ship was converted to a hospital ship and named for Blanche in July 1944.

Robot Bombs

The D-day invasion sparked the use of a new weapon by Hitler and the appearance of the term "robot bomb." Typically, bombs were carried by bomber crews on planes like B-17s, B-24s and B-29s, and pilots flew over a target to drop them. Robot bombs, or "buzz bombs," were fired from Europe across the English Channel into England and required no plane for delivery. The Germans had developed the most sophisticated rockets of the time period.

In August 1944, Helen Waterhouse reported that the first area victims of the robot bombs in England were Sergeant Stanley Dzerzynski of Boston Township and twenty-one-year-old Private First Class Alvin Newman of Hudson. Stanley and Alvin were killed along with fifteen others when a robot bomb struck their army ordnance group on May 30, 1944.

The Dirty Dozen

Thirty-eight-year-old Nick Anthes from Akron was sentenced to fifteen years in prison for selling army supplies on the black market in Paris in February 1945. A month later, 115 soldiers including Nick had their sentences commuted if they agreed to volunteer for a special unit. What that unit did—if anything—no one knows, but it is reminiscent of the 1967 World War II movie *The Dirty Dozen*, in which the men went behind enemy lines on a mission in exchange for being released from prison.

BACK FROM THE DEAD

Agnes Landrau received a telegram on August 19, 1944, informing her that her husband, paratrooper Charles Landrau Jr., had died in action during the D-day invasion. The next month, she attended the memorial service at the Rubber Bowl to honor the area war dead, including her husband. A radio broadcast out of Germany later in 1944 stated that a Charles Landbrau from Akron was a prisoner of war, but Agnes noticed that his name was spelled wrong and didn't want to get her hopes up. After several more months, the War Department called to inform her that her husband was indeed alive and a prisoner. Part of the confusion was Charles's reluctance to leave France and go to a prison camp farther away. He typically made every effort to blend in with the new prisoners or be involved in some type of work when the German guards were moving older prisoners to the rear. The Germans didn't record his name as a prisoner of war for months, as he managed to stay amongst the newly captured prisoners. On D-day, Charles said, "Everywhere there were German pillboxes blasting at us and flares searching for us." He dodged tracer bullets until he hit the ground. Surrounded by Germans, he used a grenade to take out five before being captured moments later trying to hide behind a tree.

Sergeant Casmer Walter Lekowski, who went by Walter, was a top turret gunner on a B-17 Flying Fortress. Walter's mother, Helen, was notified that her son's B-17, the *Spirit of '44*, was shot down on a mission over Holland on February 22, 1944. In March, Helen was told that her son was dead. In July, the news came that so many mothers hoped to get—her son was in a German prisoner of war camp. The Allies freed Walter on April 5, 1945. He made it home to his parents' century-old farmhouse in West Richfield in time for Mother's Day, 1945. Walter's mom enjoyed showing him her scrapbook, which included newspaper articles about his death, the government telegram announcing him as killed in action and letters of sympathy sent to his grieving family. Walter and his crew were captured immediately after they crash-landed, and they were held in a women's insane asylum for the first eleven days. The noise of the locked-up women made it hard to sleep and added to the anxiety of the men. The Germans took all their belongings, stripped them naked and threw them in beds. Walter recalled, "The waist gunner had bled seriously and I begged the doctor to give him a blood transfusion as I knew it would save his life. He refused. The waist gunner died that night." Like many prisoners of

war, Walter had to survive the constant bombing by Allied troops. The Americans bombed by day and the British at night from January until he was liberated in April. There was no way for the pilots to tell that there were Allied prisoners in the hospital where Walter was recovering from the injuries he received when he was shot down. He said, "You see the Germans painted Red Crosses on the roofs of everything in that town from breweries to ammunition works. It all seems unreal to be home, to be where there is no fear anymore."

While it was great for some families when their loved ones turned up alive, it gave false hope to many who read reports of pilots stumbling out of the jungles of the Pacific after being missing for months or sneaking through enemy-held territory for weeks with the underground in Europe. Even the toughest of men were killed in the war, and it was often hard for their families to believe they were gone.

Corporal George Popovich was a South High School football player and son of Yugoslavian immigrants who served overseas in Iceland, Africa and England in 1942. He volunteered to go back and was killed on January 8, 1945, in France at twenty-four. After his death, a funny story came back from members of his unit and was published in newspapers across the country. George was on guard duty in the Vosges Mountains on a snowy winter night, and in the dark, he felt a tap on his shoulder. He handed over his carbine to what he thought was Sergeant Herbert Thomason of Passaic, New Jersey. He then ate his K ration and went to sleep. Later, Sergeant Thomason woke George up and asked him angrily why he didn't wake him for guard duty. George was baffled and told him, "I thought you relieved me last night." The men went to find out who was on guard duty and found a bear walking back and forth with George's carbine.

Private John Schiefer was drafted in 1943 and sent his Purple Heart home to his wife when he was wounded in France. "Every step on the porch—every ring of the doorbell brings terror to the heart of Mrs. Clara Schiefer," the *Beacon Journal* headline read. He was missing in action for over a month before the dreaded telegram came on Friday, September 29, 1944. John, her husband, was killed on August 14, 1944, at the age of thirty-six in France.

Nineteen-year-old marine private Charles Edward "Eddie" Schott was killed on March 15, 1945, by sniper fire on Iwo Jima. A letter he wrote home on March 6, 1945, arrived in April. "I am still untouched. Please save clippings from newspaper about the raising of the flag on Mt. Suribachi. That was my outfit." He left behind his wife, Helen, and three-year-old daughter.

Sergeant William S. "Billy" Sutton was the youngest of thirteen kids. He had spent three years overseas when the war broke out. He then spent three years in a Japanese prison camp after he was captured defending Corregidor. The sound of planes roaring over the camp gave the men hope, but the B-29s were not there to rescue them. The planes accidentally dropped bombs on the camp, killing twenty-six-year-old Billy on December 7, 1944, in the prison camp at Mukden, Manchuria, and crushing the hopes of his return to his mother in Akron.

THE STORY OF JACK EDWARD LINK

When my grandfather John Carroll was drafted in March 1941, his best friend Jack Edward Link came down to the bus station to see him off. They graduated from Buchtel High School and attended the University of Akron together. Jack Link married Jeanette Hopkins on September 14, 1940, at St. Vincent's Church, and John Carroll was his best man.

Link, who was an accountant at Akron City Hospital, also entered the army before Pearl Harbor. In February 1942, John Carroll wrote his wife from Fort Knox, Kentucky, "It sure makes me happy to hear that Jack Link's coming here. Keep me posted on Jeanette and the baby. Is Pete planning on the army or what was the physical for?" Link was headed to Fort Knox, and friend and classmate Peter Crabb was being drafted. Link spent 1942 at Fort Knox and then Fort Chaffee, Arkansas. In December 1942, he was accepted into the Army Air Corps and sent to California for training.

In July 1943, Captain Jack Link attended advanced flying school to become a pilot officer at Stockton Field in California. He received his wings on August 30, 1943, and returned home to Akron on a ten-day leave including Labor Day weekend before being sent to Hobbes Field in New Mexico. In August 1943, Lieutenant Robert Singer had piloted one of six B-17 bombers to the Akron Airport as part of a cross-country flight from New Mexico, where he was an instructor. In September 1943, Singer was delighted when his Phi Delta Theta fraternity brother Jack Link came to the school. Singer again flew his B-17 from New Mexico to Akron on Friday, September 25, 1943, with Jack Link as his copilot. Link hoped to surprise his wife and daughter before they drove to New Mexico to join him. He was a few hours too late—Jeanette had already left for New Mexico. Singer and Link left Akron the next afternoon, and

their B-17 was back in New Mexico in plenty of time for Link to greet his family when they arrived.

In March 1944, Jeanette Link and her daughter, Joana, returned to her parents' home at 88 Eber Avenue in East Akron. Over the past two years, Jeanette and Jack had lived with their daughter on different bases throughout the country, but Jack was now headed overseas. In February 1944, Captain Link and his B-17 bomber group were held up in Maine waiting for the weather to clear. They attempted to fly to Goose Bay Air Base in Newfoundland but were turned back by a blizzard. On their second attempt, through slightly better weather, the men made it to Goose Bay despite ice forming on the wings.

When they arrived in England, Jack Link and his crew were assigned to a Nissen hut occupied by a bomber crew that had not made it back from their last mission. The men walked in and found other soldiers going through the missing crews' personal possessions and dividing things up among themselves. On May 12, 1944, Link's possessions and that of his crew would receive similar treatment after they did not return from their mission. That day, Captain Link was leading his B-17 bomber group on its thirteenth mission over Germany near Frankfurt am Main. D-day was less than a month away, and the constant bombing missions left the men exhausted. Losses had been heavy during previous raids, and they were running short on planes. Link's plane was flying fifth in the formation at twenty thousand feet with no fighter protection when he looked up and saw thirty to forty German fighters diving on them. The crew felt helpless. Link said over the radio, "Get ready, this is it." The plane caught fire in the bomb bay, and the oxygen also caught fire. The navigator, Robert Rieckelman, tore off his flak suit and oxygen mask and desperately tried to get the hatch door open. He lost consciousness and woke up falling through the air. After falling ten thousand feet, he pulled his ripcord, and his parachute opened. Robert looked up and saw parachutes above him and planes roaring off in the distance. Below, he could see the Germans gathering to take him prisoner.

In late May 1944, a letter arrived at the apartment of Dr. Charles Link and his wife, Nellie, from their son Jack. Jack told his parents that he had been on successful bombing missions, but the attacks by enemy fighters were getting intense. He closed his letter with, "If this is a corner of hell, you will all want to try to go to heaven." A few days later, on Memorial Day, 1944, the Links were notified that their son was missing in action over Germany.

Robert Rieckelman and twenty other Americans were rounded up by German soldiers, loaded onto trucks and transported to Koblenz, Germany.

Rieckelman glanced around hoping to see Jack Link or any of the other nine crewmen from his B-17. None of his other crew members were present. The men were transferred to Frankfurt from Koblenz for interrogation and found themselves amongst a large crowd of newly arrived prisoners. Allied bomber crews were subject to two weeks of solitary confinement. The Germans were so overwhelmed with prisoners taken over the previous few days that Rieckelman was lucky and was spared the two weeks of solitary. Anytime new prisoners were brought in, the men crowded around the entrance to the enclosure hoping someone else from their bomber crew would arrive. Robert and the other POWs had everything taken from them, even their wedding rings. Robert could not get his off, and neither could the Germans, so he kept his as they were transferred to a dulag (transit camp) and then a stalag (prison camp) in the summer of 1944. A healthy adult before being captured, Robert lost forty pounds in captivity, and his wedding ring eventually fell off his hand later that summer.

On January 27, 1945, with a half hour's noticed, the frantic German guards began to march their prisoners through the negative-twenty-one-degree weather as the Russians closed in on their camp. If the prisoners fell, the Germans left them to freeze to death. The men fell asleep on their feet and were shivering so badly they chipped their teeth. Rieckelman managed to stay upright, but some men didn't. "The real heroes," he said, "were the ones who walked in back and picked up those who fell along the way and helped the stragglers to keep going." Rieckelman was taken from Nuremberg to Moosburg, and at some point, the prisoners were herded into boxcars. As related by Jeanette Link, they "were strafed by Allied planes and he saw columns of freed prisoners strafed by their own men." They were constantly bombed at both places and eventually heard Allied gunfire off in the distance. They were caught in the crossfire for two days before they were finally liberated.

Robert Rieckelman was liberated from Stalag VII in Moosburg on April 29, 1945. The prisoners were flown to Le Havre, France, and then over to England. After five days, they took an eleven-day boat ride across the Atlantic, landing in Boston on May 24. Robert made it from Boston to Cincinnati, his war finally over. He called Jeanette Link on Sunday, May 27, 1945, hoping she could tell him what happened to her husband and the rest of his crew. Jeanette, though, was hoping Robert could tell her some good news. He had none—he told Jeanette that the last thing he remembered before blacking out was going for the hatch door. He had looked over his shoulder and saw the bombardier following him. He told Jeannette that the

Germans did not shoot at the parachutes, so if they escaped the plane, they should have been taken prisoner.

William Terry was a B-17 aerial gunner in the spring of 1944. Terry's first mission was on March 26, and he would fly his thirty-fourth and final mission on August 7 of that year. Seven of the original ten crew members completed all thirty-four missions and returned to the United States. Their targets were airfields, railyards, synthetic oil plants and V-1 installations in Germany, France, Belgium and Czechoslovakia. Terry kept a diary, and on May 12, 1944, on his fifteenth mission, he was part of a B-17 group that included a bomber piloted by Captain Jack Link. The target was a synthetic oilfield in Brux, Czechoslovakia. It was a nine-hour mission, seven and a half on oxygen. The men had to fly across Germany to reach their target. Terry said, "Going in we had one of those terrific sky battles, I'll never forget." A group of ME-109s engaged their P-47 fighter escort. There was "a big dogfight off to the left involving about a hundred planes, [I] saw planes going down all over the place. Then while our escort was drawn off, about seventy-five FW-190s attacked our group and the 396th, mostly at the 96th, and in a few passes, more than half of the 96th went down, about thirteen [Flying Fortresses]." Jack Link was in the 96th. The battle raged on: "They attacked us, mostly tail attacks, and they only got two of us. [I] saw [Flying Fortresses] going down all over the place, blowing up, spinning down, and breaking up. [It] looked like a paratroopers convention, chutes floating by on all sides. Really was some sight." The men got back at 5:30 after spending an entire day in the air.

On August 6, 1945, Jeanette Hopkins Link signed her familiar nickname "Hoppy" at the end of a letter she wrote to naval officer Ed Eaton, who was stationed in Frankfurt am Main, Germany. Ed was married to her Kappa Kappa Gamma sorority sister, 1932 Buchtel High graduate Helen Sherer Eaton. Helen graduated from the University of Akron in 1936 and moved with her family to Pittsburgh, where she met Eaton, the son of an undertaker. Holding out hope and not knowing how to get answers to what happened to her husband, Jeanette turned to Eaton for help. Ed wasted no time once he read her letter, and by the end of August 1945, Jeanette had the answers to what had happened to Jack and the rest of his crew.

On August 27, 1945, Eaton wrote Jeanette a long reply to two letters he received from her that month. He checked in Frankfurt for any information on his old friend and his crew but found nothing. He called the Army's Grave Registration Headquarters in Paris, and the officer there told him of a small gravesite in the small village of Hahnstatten, Germany, that the

Third Army had discovered. Eaton and another naval officer got in a jeep and made their way to Hahnstatten, about sixty miles away, just southwest of Limburg, Germany. Upon their arrival, they went straight to the village cemetery and discovered a small secluded grave in a separate section from the graves of the villagers. The men were surprised at what they saw: a foot-high, square, wrought iron fence with one nice marble gravestone inside it with beautiful flowers growing around it. The tombstone said in English, "May These American Soldiers Rest in Peace" with nine dog tag numbers listed in the middle and "Died May 12, 1944" below. Eaton read the dog tag numbers and knew this was what he was looking for.

Eaton and his companion left the cemetery and were approached by an excited old man speaking German very rapidly. They entered the old man's home and he got his granddaughter, who knew some English, to help interpret. They struggled to piece things together, but more villagers came to the home to greet their guests, and a fourteen-year-old boy who spoke good English took over interpreting.

The old man told Eaton that the B-17 had come in low a little after noon on May 12 and clipped his house before crashing fifty yards away in the hillside behind it. The villagers were unable to get inside the plane to see if anyone was alive because it was on fire. Eaton told Jeannette that the area was not a suitable place for a landing, so he doubted that Jack had control of the plane. Eaton spoke kindly of the villagers and said the old man and everyone else had tears in their eyes as they parted. "No one hates the word 'German' or 'Nazi' more than I do, but the sincere friendliness of these people, and the complete respect they had for these soldiers really made me feel that Jack and his men had been received with tender care." He went on, "In Germany, the war did not often come close to the small towns, and we gathered quite early that this was the only time that they had any excitement here during the war."

Eaton was curious about the nice burial that was given to Link and his men. "They seemed rather proud of the way the grave had been fixed with its nice marker and little fence, and when I asked them who had gone through the trouble of cutting the stone and making the iron fence they very promptly replied that the people of Hahnstatten had done that, expressing mild surprise that we would even find it necessary to ask such a question."

Jeanette was finally notified of her husband's death by the War Department in November 1945. Jack's family emphasized that he entered the army prior to Pearl Harbor and was transferred at his own request to the air corps. The family held a memorial mass at St. Vincent's Church

Left: The people of Hahnstatten, Germany, gave Jack Link and his crew a touching burial. *Personal collection.*

Below: *Left to right:* The author's grandparents John and Betty Carroll with their good friends Jack and Jeanette Link before the war. *Personal collection.*

on November 17, 1945, in Jack's honor. Jack's body and the bodies of the rest of his crew were removed from their gravesite in Hahnstatten. The men are now buried in the Netherlands American Military Cemetery in Margraten. Jack was awarded the Air Medal with an oak leaf cluster and is buried at Plot O, Row 6, grave 15.

THE CONGRESSIONAL MEDAL OF HONOR

Lieutenant Colonel Addison E. Baker's family moved to Akron from Chicago in 1918, and he attended Central High School, where he was captain of the swim team. At twenty-four, he graduated from flying school at Kelly Field in San Antonio, Texas. Akron crowds watched Baker's impressive stunt flying at the municipal airport throughout the 1930s. He often flew blindfolded in his stunt performances, which he almost had to do permanently after wrecking his car on Manchester Road in 1933—Baker fractured his skull, broke his nose and almost lost his left eye. He recovered, flew his army plane in from Detroit and married Frances Rodgers on New Year's Day, 1935. In early July 1943, he was awarded an Air Medal and the Distinguished Flying Cross for leading a squadron of Liberators on a bombing mission over Lille, France, in October 1942. Baker was Akron's only Congressional Medal of Honor recipient during World War II, though several other area men have also received the award. Baker was the pilot of the B-24 Liberator *Hell's Wench*. He flew his bomber through enemy fire on August 1, 1943, during an attack on the Ploesti oilfields in Romania. He took multiple hits but refused to pull out as he guided his group of bombers over the oil refinery targets. The bombing, Operation Tidal Wave, was as incredible as it was costly. Out of the 178 Liberators that took part that day, 53 were shot out of the sky, with 310 Allied killed and 130 wounded. Bomber planes all over the sky took fire and went down in one of the epic air raids of World War II.

On February 6, 1944, Frances Baker was on WAKR radio as the account of her husband's bombing mission at Ploesti was recounted in an effort that raised $1,688,025 in war bonds, enough to buy five bombers. The Russians captured the Ploesti oilfields and Romania in early September 1944. Frances was notified later that month that Addison was now considered killed in action after the Allied prisoners in Romania were released and Addison was not among them. Frances held out hope that Addison would turn up, acknowledging that pilots who were believed to be dead often did. She thought it was hard for families to give up since they were killed so far away from home. But the veteran pilot who cheated death many times in his life never made it home. Baker died at thirty-seven after his burning Liberator crashed just beyond the target. Addison's father, Earl Baker, an engineer at Firestone Tire & Rubber Company, and his mother, Edith, along with Frances, received Addison's Congressional Medal of Honor on March 3, 1944. The ceremony took place at First Presbyterian Church on East Market

Street, where the Bakers were active for decades. Addison himself was often in the Easter and Christmas shows, and his mom was the longtime director of religious education.

Private First Class Harold Glenn Epperson was born on July 14, 1923, in Akron and later moved to Massillon, where he attended Washington High School. Harold worked for Goodyear Aircraft Corporation before the war and lived at 310 Vaniman Avenue with his aunt Grace and uncle C.H. Epperson. He was killed at twenty years old on June 25, 1944, during the Battle of Saipan, when he fell on a grenade and absorbed the explosion to save the lives of two fellow marines who were manning a machine gun fighting off a tenacious enemy attack before dawn. On July 4, 1944, Harold was posthumously awarded the Congressional Medal of Honor in a ceremony that took place at Massillon Tiger Stadium, and on December 22 the next year, the destroyer *Epperson* was named for Harold. His mother, Jouett, and brother Seaman Bruce Epperson, who returned from Guadalcanal, christened the ship in Newark, New Jersey. Also in attendance were Epperson's father; his sister Ruth, who was also serving her country; and Harold's girlfriend Virginia Coleman of Lakewood, Ohio. Harold was with the Second Marines, which earned a Presidential Unit Citation during the Battle of Tarawa from November 20 through 24, 1943. He also received a Purple Heart and Asiatic Pacific Campaign Medal.

Staff Sergeant Howard E. Woodford was born on June 21, 1921, in Barberton. He served in the army for three years and spent two years working in intelligence for the 130th Infantry, 33rd Division in the Pacific. Sergeant Woodford volunteered to check on a delayed attack by a guerilla unit. Finding the unit taking heavy fire, he stayed to help knock out enemy guns and remove the wounded. When all the officers were killed or wounded, he took command, leading the men to take their position atop a hill. Howard organized the perimeter defense, and though he was free to return to his unit, he remained with the guerillas and helped defend the position against an overnight enemy counterattack. Wounded by a grenade, Howard directed artillery fire over the radio until it was hit with a bullet, and then he went around checking the perimeter and encouraging the men. He found a hole in the perimeter and manned it himself as hand-to-hand combat raged all around. When the sun rose, he was found dead in his foxhole with thirty-seven enemy dead around it. He was killed on June 7, 1945, near Tabio in the mountains of northern Luzon in the Philippines. Woodford had not received a furlough home during his three years in the service. The *Akron Beacon Journal* quoted him: "After this campaign a few of

us who have been over here the longest are expecting to be sent home." The telegram informing his family of his death arrived on his twenty-fourth birthday, June 21, 1945. Howard hoped to own a grocery store with his dad, who said, "Since this has happened I have given up my store for good." Woodford was the third area soldier awarded the Congressional Medal of Honor. In June 1948, a transport ship was named in his honor, and in 1958, Barberton Public Schools built Woodford Elementary School to honor him. In 1962, the army reserve center at Waterloo Road and Kelly Avenue in Akron was also named for him. In 2016, Howard's nephew Jack came to town to dedicate a granite marker at the Ohio Veteran's Memorial Park in Clinton and see his uncle inducted into the Barberton Walk of Fame on Tuscarawas Street in front of Lake 8 Cinemas.

THE THIRTY-SEVENTH DIVISION

On October 21, 1940, Akronites crowded Union Station as the 345 Akron National Guardsmen of the 145th Infantry were sent down to Camp Shelby in Mississippi. The guardsmen would be part of the 37th Division, an all-Ohio unit nicknamed the "Buckeye Division." The *Beacon Journal* asked where these men would be in a year. As the National Guard and reserve troops were sent off for training, America was also beginning its peacetime draft. Guardsmen and draftees alike were required to be trained for one year and sent back home unless war broke out. As the crowd waved goodbye to the men, many wondered if they would ever return to Akron.

The *Beacon Journal* also reported that with conscription starting, these sad farewells at the train station would be repeated over and over again. The paper reminded readers that the men in the army had no voice and had to follow orders:

> *The guardsmen are in the army now, and the draftees will be soon. They will go where their superiors send them and fight whom they are ordered to fight. Barred by the rules of military discipline from voicing any dissenting opinions of their own, they leave their safety in the hands of Americans at home. It is up to the home to demand, and to keep on demanding, that the government court no war in Europe or Asia, but rather to use the huge new army for the purpose for which it was intended—national defense.*

Like all the others called up before Pearl Harbor, the men of the Thirty-Seventh Division would not return home in one year. On October 4, 1945, almost five years later, the men of the Thirty-Seventh began returning by bus and train to the place they called home back in 1940. The Thirty-Seventh went overseas on May 26, 1942, and spent forty months fighting in the Pacific. Private First Class Robert Yeager was the first to receive his discharge at Camp Atterbury in Indiana and arrived at Union Station at 2:33 a.m. on October 4, 1945. Asked about his return to Akron, Robert said, "Good? Hell, it's wonderful! I know this neighborhood. This is where I've dreamed of being." Men from Akron poured off the train to hugs and kisses and women they planned to marry. Jack Vincione, who won a state championship in 1932 on West High's basketball team, was one of the happy men celebrating with family and friends—they were all there to greet him after he sent a telegram reading "Back from hell into heaven" to announce he'd be home soon. He couldn't wait to sleep in a bed, exclaiming that "This is the first time I have been in a house since we left." Hour after hour, men from the Thirty-Seventh who had fought through every Pacific campaign together streamed off the trains, with hundreds of Akronites returning. Families would ask anxiously for news of loved ones not home yet, and the men would gladly update them, assuring them they'd be home soon. Asked by a reporter, the men said, "You see, we all were buddies over there. We knew everyone from Akron—from the old National Guard outfit and from working together in the Pacific." The family of Corporal John Makiel was there to greet every train, not knowing when he would arrive. The reporter noted, "John was coming home—and they'd meet every train until he arrived. He, too, had been gone the 40 months." The war was finally over for these men. The headline said it best: "They're Home, Akron, Your Heroes of 37th!"

The Thirty-Seventh had a long journey ahead of it in 1940. When it left, the *Beacon Journal* pointed out that "A year is a long time for a young man to be away from his family." The army was not the place many of these men wanted to be, and being stationed so far from home took its toll on all the soldiers. When Private Alton Beans was found hanging in a tent, having committed suicide at twenty-one on January 5, 1941, men in his outfit said he was so happy when he returned home for Christmas. He had been despondent since his return to camp after the new year and took his life. These men had no options; as the *Beacon Journal* stated, they could not go home if they wanted to. They followed orders, and throughout World War II, men from the Akron area occasionally took their lives.

The longer the Thirty-Seventh Division stayed overseas, the more families grew concerned for their wellbeing. Secretary of War Henry Stimson said in August 1944 that they could not be brought back yet due to lack of available shipping and replacements. According to the *Beacon Journal*, Ohio congressmen had been receiving "pleas from families of the 37th Division members that the veterans be brought to the United States and replaced with fresh troops. The division was mustered into service before Pearl Harbor and has seen some of the war's bloodiest fighting." Many of the worst fears came true for families, as throughout the war, members of the Thirty-Seventh were killed in action. Sergeant Fred George, killed on April 20, 1945, at the age of twenty-seven after forty months overseas, and Sergeant Wayne Crisplip, killed on Luzon after thirty-five months overseas, are just a couple of examples.

One Akronite, First Sergeant Francis Thomas, distinguished himself as the leader of his company. He commanded 120 men, including 38 from Akron. He turned down opportunities to become an officer and, as his buddies from Akron joked, was the longest-serving first sergeant in the army. He led the men through the New Georgia and Bougainville campaigns with no casualties on New Georgia and only five on Bougainville.

Some members of the Thirty-Seventh came home for Christmas in late November 1944. Two hundred and fifty-one men who had fought thirty straight months overseas were allowed to return home for furlough, including sixteen from the Akron area. After their furlough was over, they were either sent back overseas or given a post stateside. Reporters from Ohio greeted the men as they arrived in California to find out how it felt to be home. The men didn't know who had been elected governor of Ohio a few weeks before and were eager to get home to see snow and throw a snowball. Louis Clifford for the *Akron Beacon Journal* wrote: "When we met the men in California we had some 24-hour-old editions of Ohio newspapers and it was almost pathetic to see the eagerness with which they read them from front to back." Staff Sergeant Robert Haehn of Cleveland was asked how he felt about going home and said, "Well I'll tell you, I've been away thirty months. My son is twenty-seven months old. Does that tell you how I feel?" There was a story traveling through the train cars that caught a *Beacon Journal* reporter's interest about a soldier who phoned home at a train stop: "He talked to his wife, then she put the baby on the phone. He's never seen the kid and when the boy said, 'Hello, Daddy,' the poor guy keeled over." The men didn't want to talk about the war. There was more talking about the baseball games on Bougainville than about the fighting. The men felt bad about buddies

they had left behind in the jungles who hadn't been lucky enough to get a furlough home after thirty months like they did. "These men are all very tired, and not just tired from a long slow train ride. They're tired in spirit and mind," reported the *Beacon Journal*.

More men from the 37th Division arrived by boat in California on December 5, 1945, including Captain Morgan Griffith, who with 136 points was well over the 80 needed to be discharged. Points were based on length of service and how much time a soldier spent overseas. Parenthood, combat awards and battle participation stars also counted. Those with the most points would be released first. It was common for soldiers who had enough points to go home to have to wait for replacements or room on a ship before they would be rotated home. There were many men killed in action—including some from Akron—who had more than enough points to return home. Griffith, who was from Copley and served in the 148th Infantry, had never seen his three-year-old daughter. The 37th fought in the jungles of the Pacific longer than any other unit.

ATHLETES DURING WORLD WAR II

Martins Ferry High School won the state basketball championship in 1941 under the leadership of Lou "Big Chief" Groza. He would become a hall-of-fame football player and Cleveland Browns legend after World War II. During the 1940–41 basketball season, Groza's Martins Ferry team only lost twice, once to Steubenville and once to Akron South High School. That South team that beat Groza included two future collegiate All-Americans in Wyndol Gray and Fritz Nagy as well as future Notre Dame head football coach Ara Parseghian. Wyndol Gray, who set an Akron City Series record for points scored in a season, scored twenty-one of South's thirty-five points to lead his team past Groza's by three points.

On March 11, 1944, Lieutenant Paul E. Brown passed his physical exam and was drafted into the navy at the age of thirty-five despite being married and having three sons. The renowned former Massillon Washington High School coach was given a leave of absence from Ohio State University, which he had led to its first national title in 1942. Brown was not alone, for high school and collegiate coaches throughout Ohio and the country were drafted during the war.

The Great Lakes Navy Station had a football team, and it wasn't long before Lieutenant Brown was its coach. He took over for former University of Chicago All-American athlete, Butler University coach and navy lieutenant commander Paul "Tony" Hinkle in August 1944. Great Lakes Naval Station prepared to train forty-five thousand men at the start of World War II and asked Butler University for Hinkle's help. Hinkle joined

Lieutenant Paul Brown coaches football at Great Lakes Naval Station in 1944. The Ohio State coach and father of three was drafted in April 1944. *From the* Columbus Citizens Journal, *Grandview Heights Public Library/Photohio.org.*

the navy in March 1942. In his final football game of the 1943 season, Coach Hinkle and the Great Lakes Bluejackets pulled off a 19–14 upset over Notre Dame. The forty-five-year-old Hinkle stayed on as an athletic officer until he was sent to the South Pacific in October 1944. He returned to Butler in 1946, where he was athletic director and coached the basketball,

Future Notre Dame coach and 1941 South High grad Ara Parseghian at Great Lakes Naval Station. *Reprinted with permission of the* Akron Beacon Journal *and Ohio.com.*

baseball and football teams from 1921 until he retired in 1970. In his last game at Hinkle Fieldhouse on February 23, 1970, fans packed the arena as his basketball squad almost upset Notre Dame. Notre Dame's team captain and future Cleveland Cavalier Austin Carr scored a Hinkle Fieldhouse–record 50 points to hold off the Butler Bulldogs 121–114.

One of the local players at the Great Lakes Naval Station was South High School's Ara Parseghian, who attended the University of Akron before entering the service. He would later become an All-American at Miami University in Ohio and played under Paul Brown with the Cleveland Browns for two years. Parseghian, the son of an Armenian immigrant father and French immigrant mother, would become the second-winningest coach at Notre Dame University behind the legendary Knute Rockne, winning two national titles for the Irish. Ara's dad was a World War I veteran and is buried in Rose Hill Burial Park.

Fans packed the Shoe in Columbus on Saturday, October 21, 1944, when Paul Brown led his undefeated Great Lakes Naval Training Station team against Ohio State. Carroll Widdoes, Brown's longtime assistant at Massillon High School and Ohio State, was now leading the Buckeyes, and Paul Brown found himself in an unfamiliar place. He said, "This will be the first time I have ever been in the visitors' dressing room at Ohio State. I'll be anxious to see what it looks like." There were 73,477 fans watching as the Buckeyes beat Paul Brown's Bluejackets 26–6 by scoring three touchdowns in the final quarter. Carroll Widdoes's parents were in the Philippines as missionaries at the start of the war and were prisoners of the Japanese for eight months.

Talented fullback Lee Tressel out of Ada, Ohio, was on Paul Brown's team at Ohio State during the war. Fans were excited when Lee put up two touchdowns in the spring game of 1943, but Paul Brown announced after the game that Lee would be called by the army in July. This actually

Coach Paul Brown plays with his three sons on April 15, 1944. He was scheduled to report for duty on Monday April 17, 1944, after being drafted. *From the* Columbus Citizens Journal, *Grandview Heights Public Library/Photohio.org.*

meant that Lee was headed to Baldwin Wallace University to begin the navy's V-12 officer training program. Tressel could still play football but not for Ohio State. He transferred along with three other Ohio State players, including former Barberton star Jim Culbertson, to the navy's program at Baldwin Wallace. "It begins to look as though Paul Brown will have to come to Berea to see his Ohio State football team play this fall. They will be wearing Baldwin Wallace uniforms, however," said a *Beacon Journal* article from June 10 of that year. After the war, Lee Tressel had a successful football coaching career at Mentor and Paul Brown's Massillon Washington High School before landing the head coaching job at Baldwin Wallace. Jim Tressel, Lee's son, was born in Mentor, Ohio, and graduated from Berea High School in 1971 before playing for his dad at Baldwin Wallace. Coach Jim Tressel made the sweater vest famous and coached at the Ohio State University. Jim Tressel won a national championship in his first season as Ohio State's coach in 2002.

In February 1945, it was announced that Lieutenant Paul Brown had accepted the head coaching job of a newly formed Cleveland professional football team while still in the navy. With a five-year contract, Brown was now the highest paid football coach in the country; he was reportedly paid $25,000 annually. He was also given a percentage of the team's profits, which led to speculation he could earn between $60,000 and $75,000 per year. Ohio State, already upset that Brown would not return to coach the Buckeyes after the war, was even more upset when he signed former Buckeye Lou Groza to a contract in Cleveland while Groza was serving in the army medical corps in the Philippines. Brown also signed Second Lieutenant Lou Saban, an Indiana linebacker.

Paul Brown didn't want the team named for him, but in the end, other names didn't work out. Most people in a contest held to win a $1,000 war bond suggested naming the team for Brown. The first game the Cleveland Browns ever played was during preseason in 1946, when 36,000 fans packed the Rubber Bowl in Akron to watch the team take on the Brooklyn Dodgers. The Browns won 35–20, scoring 28 points in the second half. The Browns drew 619,314 fans at their home games their first season and sold $1,025,000 in tickets. No professional football team had ever drawn this many fans or grossed over $1 million in tickets sales.

Future hall-of-famer and Cleveland Brown Otto Graham left Northwestern for V-5 navy officer training at Colgate University in 1944. He was team captain of the Northwestern basketball team one week and playing ball for Colgate the next. He played basketball there and by the fall was playing football for the North Carolina Preflight Cloudbusters. Marion Motley, another future hall-of-famer and Cleveland Brown, attended Canton McKinley High School and the University of Nevada. He also ended up playing for the Great Lakes Bluejackets. In his final game for the Bluejackets on December 1, 1945, he helped rout Notre Dame 39–7. Marion Motley and Bill Willis, African American stars of the Browns in 1946, were not allowed to play against the Miami Seahawks in Florida.

As for Ohio State, in another twist, assistant coach and former University of Akron coach Paul Bixler took over for Carroll Widdoes, who was made an assistant coach. Coach Bixler left Ohio State to coach at Colgate after an embarrassing 58–6 loss to Michigan in November 1946. In August 1945, while preparing for the football season, Ohio State announced that among the 15,470 Ohio State students in the service were 905 varsity athletes; 537 Buckeyes had died at that point in the war, with 96 missing and another 90 listed as prisoners of war. Three of

the dead were members of Ohio State's football team. Lieutenant Eddie Blickle, an assistant coach, was also killed.

The Cleveland Indians star pitcher Bob Feller missed being called to service by one spot in November 1941 as part of the last draft call scheduled to report on December 1. In late November, Feller's mom wrote the draft board that his parents were in ill health and, along with his sister, were dependent upon his wages, suggesting he be deferred. The Cleveland Indians expected Feller to be drafted in the first draft call of 1942 and to lose their ace pitcher for the 1942 season. Feller enlisted in the navy just before Pearl Harbor instead of waiting for the draft to resume in January 1942.

JOURNALISTS AT WAR

John S. Knight

In 1903, Charles Landon Knight, known to his friends as C.L., came to Akron as part-owner of the *Akron Beacon Journal*, which he bought full ownership of in 1909. A Roosevelt Republican, the only person Knight hated more than Woodrow Wilson might have been President William Howard Taft. Woodrow Wilson narrowly beat former president Teddy Roosevelt in Akron in the 1912 presidential election. Roosevelt ran as a progressive, socialist Eugene Debs came in third, and the unpopular incumbent President Taft was fourth in Summit County.

C.L.'s son John S. Knight left Cornell University and became a lieutenant in the 113th Infantry, 29th Division, during World War I. He never finished college and became one the most prominent newspapermen in the country without a degree. He finished his eighteen-month overseas service in France as an observer for the Army Air Service.

C.L. Knight was elected to Congress in 1920 and went to Washington, D.C., along with his close friend President Warren Harding. He hated every minute of it and returned to the *Beacon Journal* when his term was up in 1923. After John returned from the war, C.L. Knight asked him to follow in his footsteps and work for the *Beacon Journal*. John S. Knight agreed under two conditions: if he didn't like it, he could quit, and if he wasn't any good, his dad would fire him.

John S. Knight during World War I.
Reprinted with permission of the Akron Beacon Journal *and Ohio.com.*

In 1933, longtime friend Clarence Darrow came to Akron to attend C.L. Knight's funeral. After C.L.'s death, the Akron *Times Press* looked to put his son John S. Knight out of business. It didn't happen—Knight bought the *Times Press* in 1938 and moved the *Beacon Journal's* headquarters on Market Street into the *Times Press's* building on Exchange Street, where the paper is located today. After winning what the newspaperman called the "Battle of Akron," John S. Knight resigned from the Republican Party. A man of tremendous integrity, he said it was his duty now that he owned the only newspaper in Akron to report the news in a thoughtful and unbiased manner. He didn't want to be a mouthpiece for any one political party.

Both C.L. and John S. Knight were well known for their editorials. John S. Knight wrote a light-hearted yet serious editor's note on June 7, 1942, to the first spring graduating class of the war. In it, Knight spoke of how it was customary for the older generation to apologize for its failures and to encourage the younger generation to work hard and succeed where it had failed:

> *This year, graduation time has particularly poignant memories for those of us who left school to serve in the Great World War and who now have sons who are being sent forth to fight for the things that were supposed to be won on the battlefields of Europe in 1917–1918. Selfish men of nearly every world power must share the responsibility for this war. Their greed and personal ambitions made lasting peace impossible wherever men preferred liberty to slavery, wherever they chose to die rather than submit to a dictator's plan of life. The world must look to the young men to end this most horrible of wars.*

John S. Knight's editorial had special meaning: his son John S. Knight Jr. graduated in 1942 from Culver Military Academy, where he was the captain of the cross-country, boxing and track and field teams. After receiving his

John S. Knight speaks with Eleanor Roosevelt outside the Akron armory in the 1930s. *Reprinted with permission of the* Akron Beacon Journal *and Ohio.com.*

diploma, he entered the service and became a paratrooper. He married Dorothy Wells on November 20, 1943. Knight distinguished himself on the battlefields of Europe and was awarded a Bronze Star for leading a reconnaissance patrol in Belgium on January 21, 1945. Two months later, on March 29, 1945, John S. Knight Jr. was killed along with four other men when their patrol was ambushed outside of Hullern, Germany.

John S. Knight Sr. turned into one of the area's grieving fathers as the death toll during the last months of the war became staggering. "When Johnny Couldn't Come Marching Home Again" was the headline recapping John S. Knight Jr.'s death in the April 24, 1945 *Akron Beacon Journal*. In tribute to his son, Knight opened with "Johnny is gone. The lovable, kindly kid who never had a vicious thought in his life is sleeping in Germany." He went on to list some of the reasons why, including, "because those of us in all lands who fought the last time failed to insure a lasting peace."

Amazingly enough, John S. Knight continued to be active in world affairs and deeply involved in the war. Maybe he wanted to see to it that the work

The class of 1942 graduates and gets more than a diploma. *Reprinted with permission of the* Akron Beacon Journal *and Ohio.com.*

of his son and so many other sons in this terrible war, as he often called it, didn't go unfinished. Knight Sr. was chosen as the liaison for the office of American censorship in April 1943 and was sent to London until April 1944. There, he was in charge of working with his British counterparts to speed up and improve the transmission of war news from all fronts to American newspapers and readers.

In August 1945, John S. Knight traveled over thirty thousand miles touring army and navy bases throughout the Pacific for over a month with

Richard Nixon and John S. Knight III at the Soapbox Derby in 1959. Knight III was born two weeks after his dad was killed in Germany. *Reprinted with permission of the* Akron Beacon Journal *and Ohio.com.*

Brigadier General Julius Ochs Adler of the *New York Times* and John Cowles, the publisher of the *Minneapolis Star Journal*. He first stopped at Pearl Harbor, where he ran into World War I navy flying ace and native Celevander Captain David Ingalls, who was the commander of the airfield. They met up with Vice Admiral John Hoover, who was born in nearby Seville, Ohio. The next day, Knight was on a twenty-hour flight to Guam to see Admiral Chester Nimitz.

Knight met many generals and admirals and had this to say:

> *MacArthur black-haired and erect anxious to talk about military history and strategy. Admiral Nimitz benign in manner, while sitting with him at dinner he reminds you of a bishop but the officers tell you he can be very tough. General Kenney would have kept us there all night showing us maps. I never saw a more dynamic man. General Doolittle a hard hitter who came too late to get into the final push. He wanted to be remembered to his Akron friends. General Wainwright looks like a ghost. General LeMay,*

Left to right: An unidentified man, John Cowles Sr., John S. Knight, Fleet Admiral Chester Nimitz and Julius Adler on Knight's 1945 tour of the Pacific. *John S. Knight Papers, Archival Services, the University of Akron, Akron, Ohio.*

big, tough, cigar-chewing, another hard hitter. "Uncle Joe" Stilwell looks like an unpressed G.I. right out of Arkansas. He has no love for Chiang Kai-Shek. General Spaatz, older and grayer than when I saw him in London. Admiral Halsey—you mention his name to the enlisted men and immediately their ears prick up. They have a great respect for him. One Akron man was making a name for himself there. He was Colonel Don Carney who was the chief of staff for the B-29 base. I can say that he had something to do with the picking the crew that dropped the atomic bombs.

When he was in Manila in mid-August 1945, he visited with General Douglas MacArthur: "It is amazing to see the respect given him by the people. They stop and salute as his car passes." Knight was in Manila when the first Japanese envoy visited to negotiate the surrender of Japan, which would be signed on the *Missouri* two weeks later. John S. Knight was on the

Left to right: John Cowles Sr., John S. Knight, General James Doolittle, Julius O. Adler and Dolittle's chief of staff on Okinawa, 1945. *John S. Knight Papers, Archival Services, the University of Akron, Akron, Ohio.*

battleship *Missouri* seated by a gun turret twenty-five feet from where the surrender was signed.

On September 27, 1945, in front of a sold-out crowd at the Mayflower Hotel, Knight told Akronites of his journey throughout the Pacific and of the Japanese surrender. Knight defended General MacArthur, saying he was doing a great job, and that keeping Emperor Hirohito on the throne was necessary and may have saved America from several hundred thousand casualties. The American occupation forces had not had one soldier killed yet, which Knight attributed to General MacArthur working with Emperor Hirohito. On the same day as Knight's Mayflower speech, it was reported that the ashes of three of General Doolittle's raiders had been found in China, where they had been captured and executed following the famous 1942 raid.

In December 1945, John S. Knight and other newspaper editors were in Washington, D.C., where he met with President Truman, General Marshall and General Eisenhower. General Eisenhower had just taken General Marshall's place as the chief of staff for the army.

John S. Knight *(right)* and General Dwight Eisenhower *(center). Reprinted with permission of the* Akron Beacon Journal *and Ohio.com.*

John S. Knight *(right)* and General George C. Marshall *(left). John S. Knight Papers, Archival Services, tThe University of Akron, Akron, Ohio.*

John S. Knight *(fourth from left)* in the Oval Office with President Truman *(center)* in 1945. *Reprinted with permission of the Akron Beacon Journal and Ohio.com.*

WEB BROWN

Spanish-American War veteran and *Beacon Journal* political cartoonist Web Brown was another newspaperman leading the fight at home against the evils of war. Like John S. Knight and the World War I generation, Web Brown and the Spanish-American War generation had no love for war. Web led the fight against the enemy while puffing on his cigar and turning out some of the country's best political cartoons of the era.

Daniel Webster Brown was born on January 28, 1876, on Vine Street in downtown Akron. Web's mother died when he was one, and he was raised by his grandmother in a fifteen-room house on Bowery Street across from the YMCA. Web graduated from Jennings High School on Summit Street and attended Buchtel College for one year. He previously worked in an architect's office tracing drawings. In 1898, Web headed off to war. Upon his return, Web pursued his dream to be a political cartoonist. In 1899, he went to the Akron *Democrat*, run by Ed Harter, and asked to be hired as a political cartoonist, since Harter didn't have one. Harter said he couldn't afford one, and Web volunteered to work a year for free. Harter told Web he'd hire him for $12 a week and gave him his first assignment. Web, who had no experience, worked from 10:00 a.m. until 1:00 a.m. on his first cartoon. He told his wife he thought the cartoon was no good, and

she suggested he go thank Harter for the job offer and quit. Web brought his cartoon to Harter's office, and before he could say a word, Harter was dying with laughter. "You know he thought it was wonderful. And so I didn't quit," said Web.

Web went on to become one of the best political cartoonists in the country at one of the best newspapers in the country, the *Akron Beacon Journal*. If there was a political cartoonist hall of fame, Web would be in it. During World War II, with over forty years of drawing under his belt, was when Web was at his best. Throughout this book are some of the best political cartoons drawn during World War II from quite possibly the best cartoonist of the time. The cigar-smoking cartoonist retired after the war, publishing his last cartoon on Christmas Eve, 1945. Web died on March 4, 1974, at ninety-eight.

KEYES BEECH

Keyes Beech was born in Tennessee and grew up in Florida. Keyes dropped out of school in junior high to help his sister support their family when his father's health was failing. His sister got a job in the classified ad department at a local newspaper, and it wasn't long before he followed as a copy boy. The ambitious young man turned out to be a top-notch reporter. After five years, in 1937, he took a job with the *Akron Beacon Journal*. In 1942, Beech trained at Parris Island, South Carolina, before heading to Washington, D.C., to train as a combat correspondent with the marines. When asked if he was ready for combat in the Pacific, he commented to his *Beacon Journal* coworkers that he thought the Goodyear riot of 1938 was good preparation.

Keyes first took part in the bloody fighting on Tarawa. "Tarawa was bad. But not too bad, because I didn't know how easy it was to get killed on Tarawa." He was the first combat correspondent to reach Mount Suribachi on Iwo Jima. It was reported that he took part in the famous flag-raising atop the mountain, but when asked, he said, "Hell, no. I didn't help raise that flag, I was fifty feet away ducking grenades." After the Battle of Iwo Jima, Keyes was picked from the combat correspondents of the Fifth Marine Division to tell the story. Five days after the battle ended, he was in Washington, D.C., to work with several other writers and public relations experts in putting the story of Iwo Jima into book form. Keyes said the battle "was like a badly written play. It seemed like it should have ended on Suribachi. But it didn't." The book Keyes coauthored, *The U.S. Marines on Iwo Jima*, was published in

1945. Other books written by Keyes include *Tokyo and Points East* in 1954, *Uncommon Valor* and *Not without the Americans* in 1971.

Keyes wrote a tribute to his friend, twenty-four-year-old Staff Sergeant William Vessey of Oregon City, Oregon. On Iwo Jima, 4,300 marines were killed in twenty-six days. Vessey was killed on the second day of the battle:

> *I would like to tell you about my friend. He died about 15 minutes ago, but he had been dying for two hours. There is something very strange about this, my friend. This pitiful thing with the mangled legs and arms cannot be you. You belong over in that foxhole next to mine. Remember how only three hours ago, we were sitting there talking, we were watching the planes as they swept down on Mount Suribachi. And you were saying, "this will be one to tell the kid about."*
>
> *What WAS that you were telling me about the kid? Oh, yes. You received a brand-new set of pictures of him while we were still aboard ship. You had such a lot to live for, my friend. The wife—she doesn't know she's a widow yet—and that baby boy you had seen perhaps a half dozen times.*

Marine combat correspondent and *Akron Beacon Journal* reporter Keyes Beech on Iwo Jima. *Reprinted with permission of the Akron Beacon Journal and Ohio.com.*

It is sad to think he won't even remember you. But they say it's better that way. I wouldn't know. I wish there were something I could do for you, but there isn't. You don't need me anymore.

Keyes Beech was at the Mayflower Hotel in town with actor Walter Pidgeon on May 14, 1945, to kick off the seventh war loan campaign, featuring the flag-raising on Iwo Jima and the slogan "All Together Now." Summit County's goal for the drive was $22,520,000. On May 17, 1945, the three surviving members of the Iwo Jima flag-raising—Private First Class Rene Gagnon, Pharmacist Mate Second Class John H. Bradley and Private First Class Ira H. Hayes—were introduced by Tech Sergeant Keyes Beech at Akron's Loew's Theatre. Keyes talked about how people were saying the

Left to right: Dean Chatlain, marine combat correspondent Keyes Beech and actor Walter Pidgeon in Akron for a war bond drive in 1945. *Reprinted with permission of the* Akron Beacon Journal *and Ohio.com.*

war would soon be over after the German surrender on May 8. "Such news would be a great surprise to the guys getting shot on Okinawa tonight and tomorrow night." The war bond rally, which featured short speeches by the men and a viewing of the original flag that blew at the top of Mount Suribachi, raised $50,000 that night at Loew's. The three men autographed every war bond purchased, and with every bond, a color picture of the flag-raising was given out. Keyes and the three surviving flag-raisers toured the United States selling war bonds, a tour that was featured in the 2007 Oscar-nominated film *Flags of Our Fathers* (John Benjamin Hickey plays Keyes Beech). Keyes was in charge of public relations and managing the tour.

Keyes won a Pulitzer Prize in 1951 for his coverage of the Korean War for the Chicago *Daily News* foreign service—not bad for a man who never attended high school.

LOUIS BROMFIELD

Louis Bromfield served in World War I and owned a 5-acre farm in France in the 1920s, when he introduced the French to crops like Ohio's sweet corn. Bromfield had not planned to leave France, but then one night came the order to keep window shades drawn in the town of Senlis. The army later commandeered his vehicle as it moved into the area. He decided it was time to return to Ohio, and after an exhaustive search, in 1938, the bestselling, Pulitzer Prize–winning author found a 365-acre piece of land near his native Mansfield. He loved the land and offered the owner $37,000. Bromfield had an agricultural degree from Cornell University and became a pioneer in organic gardening. He named his new farm Malabar after the location in his latest novel, *The Rains Came*.

Upon his return from Europe, Bromfield had this to say:

> *The peace of Munich, so-called, is the phoniest peace in history. England's prime minister, Neville Chamberlain, is the most dangerous man in the world, a liar, a double-crosser, a conniver against democracy and the peace of the world, and anything else that one can think to call him. This is not only true of him, but of the other members of his government.*

Bromfield's Malabar Farm is famous as the location of the May 21, 1945 wedding of Humphrey Bogart and Lauren Bacall. Bogart was the Oscar-

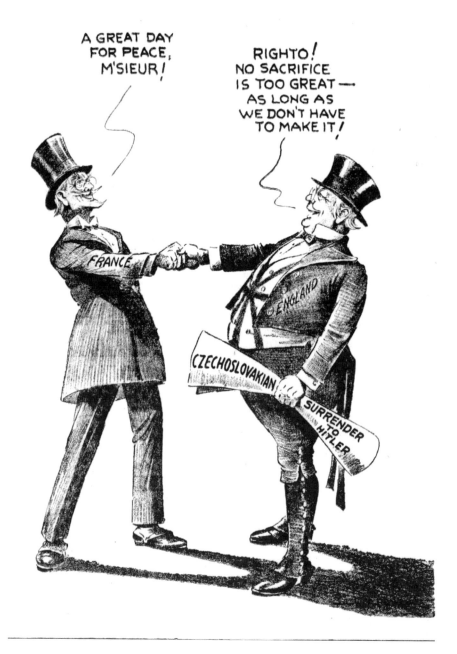

In what was not their finest hour, Britain and France surrendered Czechoslovakia to Hitler. *Reprinted with permission of the* Akron Beacon Journal *and Ohio.com.*

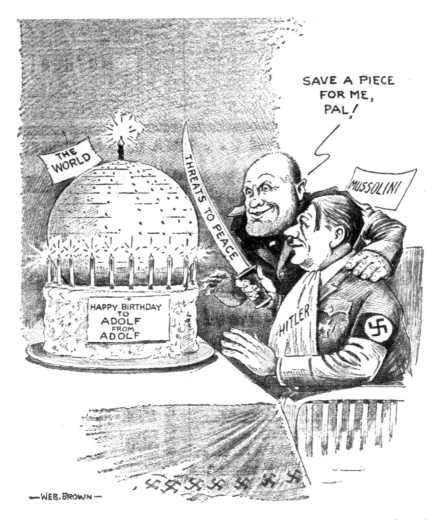

Hitler continues to threaten the world. *Reprinted with permission of the* Akron Beacon Journal *and Ohio.com.*

nominated star of World War II–era *Casablanca*, which won Oscars for Best Picture, Best Director and Best Writing, Screenplay.

Bromfield wasn't the only author in the news in the late 1930s. An author with a more sinister name was outselling Bromfield in his own country. In April 1939, *Publisher's Weekly* announced March's top-selling nonfiction books based on statistics from 103 book sellers in seventy-three U.S. cities. The number-one-selling nonfiction author in the United States was Adolf Hitler with *Mein Kampf.*

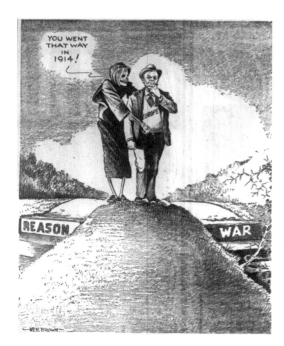

Left: Death and Europe discuss which way he is going to go in August 1939. *Reprinted with permission of the* Akron Beacon Journal *and Ohio.com.*

Below: Louis Bromfield sits at the desk that every author should have at Malabar Farm. Bromfield returned from France due to the war. *Reprinted with permission of the* Akron Beacon Journal *and Ohio.com.*

HELEN WATERHOUSE

Helen Waterhouse was the first female reporter in the United States to cover aviation with her column "Wings Over Akron." She started out as a freelance writer, but it was said that John S. Knight was buying so many of her articles that she was making more than his own reporters. Knight offered Helen a salaried position at the *Akron Beacon Journal*, and she accepted. The thrifty and dedicated reporter spent too much time at her chosen profession, and her husband, Ralph Waterhouse, the superintendent of Akron Public Schools, sued her for divorce in 1940, charging her with neglect.

Helen interviewed Eleanor Roosevelt in 1934 and sent back a picture of herself straddling the thirty-eighth parallel when she covered the Korean War in 1951. During World War II, Helen chased down war stories all over Akron. The first B-29 Superfortress to visit Akron during the war took Helen for a ride throughout Ohio. She often was given the difficult task of talking with families when their loved ones were wounded, missing in action or had

Akron Beacon Journal reporter Helen Waterhouse interviews Eleanor Roosevelt in the 1930s. *Reprinted with permission of the* Akron Beacon Journal *and Ohio.com.*

Akron Beacon Journal reporter Helen Waterhouse stands on the thirty-eighth parallel as she covers the Korean War. *Reprinted with permission of the* Akron Beacon Journal *and Ohio.com.*

Dr. Sam Shepard kisses *Akron Beacon Journal* reporter Helen Waterhouse after being released from prison. *Reprinted with permission of the* Akron Beacon Journal *and Ohio.com.*

become prisoners of war. Helen had to tackle the toughest job of all during the war—writing about the Akron-area war dead became a daily task for her throughout 1944 and 1945. "Three Babies from the Akron Area Are Left Fatherless as the Relentless Toll of War Goes On" was her September 24, 1944 *Akron Beacon Journal* headline.

Helen's son George Waterhouse, known as "Bud," served three years overseas with the marines, participating in the invasion of Guam and

surviving the bloody Battle of Iwo Jima. Bud wrote his mom that he was losing weight, getting three hours of sleep and didn't want to talk about the eighteen days of fighting he had been through so far except to say it was a bloody mess.

On June 13, 1965, Helen was headed to downtown Akron to interview attorney F. Lee Bailey about Dr. Sam Shepard's case when she crashed her car into a telephone pole on West Exchange Street. It is thought she had a heart attack. Helen Waterhouse, the legendary reporter who often drove her editors crazy by not playing by the rules, died at seventy-three doing what she loved. The *Akron Beacon Journal* said it best in recapping her career on November 19, 1978: "Helen died as she wanted to live—on the front page." Among those who attended her funeral was Dr. Sam Shepard, whose trial was covered by Helen when he was acquitted of murdering his wife in Bay Village.

Ernie Pyle and the Story of GI Joe

America's—and Akron's—most popular war correspondent was Ernie Pyle. His weekly nationwide column reporting on the life and heroics of the ordinary soldier won over millions of readers, including many who read him in the *Beacon Journal*. But after twenty-nine months of war coverage, Ernie had enough, and he was coming home.

The *Beacon Journal* asked, "Why is Ernie quitting now, with victory apparently so near?" Ernie said it best: "All of the sudden it seemed to me if I heard one more shot or saw one more dead man, I would go off my nut. And if I had to write one more column, I'd collapse, so I'm on my way."

Pyle was not from Akron (he was born in rural Indiana), but a native Akronite helped bring the Hoosier correspondent's story to the silver screen. Lester Cowan grew up selling the *Beacon Journal* on the corner of Main and Mill Streets while working his way through the University of Akron after graduating from South High School in 1922. He left the University of Akron just before graduating and went to California, where he graduated from Stanford University. In 1931, Cowan was appointed executive secretary of the Academy of Motion Picture Arts and Sciences, where he helped develop the Academy Awards. He left in 1933 and began his career as a movie producer.

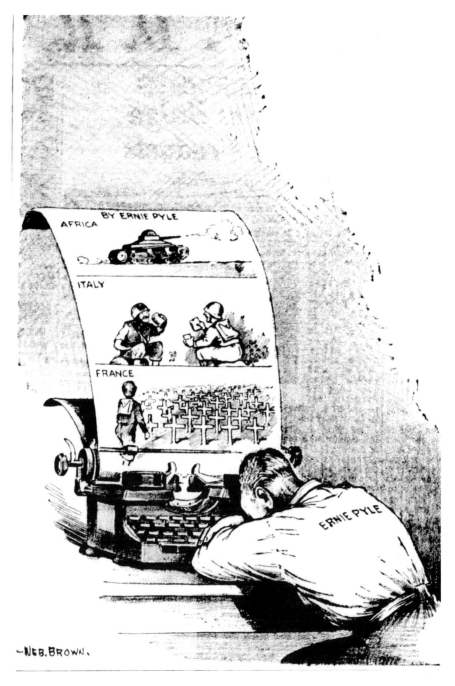

Ernie Pyle returns form the European battlefronts. *Reprinted with permission of the* Akron Beacon Journal *and Ohio.com.*

In 1935, he produced *The Whole Town's Talking*, starring Edward G. Robinson and directed by John Ford. He produced two movies starring W.C. Fields, *You Can't Cheat an Honest Man* in 1939 and *My Little Chickadee* in 1940. Cowan's next two movies, *Ladies in Retirement* in 1941 and *Commandos Strike at Dawn*, received Oscar nominations. *Commandos Strike at Dawn* was his first war movie, and it was followed by *Tomorrow, the World!*

In 1943, West High grad and actor Jesse Weidenfeld, known by his stage name, Jesse White, ran into Lester Cowan in New York. Cowan had just come from interviewing Madame Chiang Kai-Shek in Washington, D.C., about the possibility of making a movie about her life. Jesse White's career was starting to take off in New York, and by 1945, he landed his famous role as a hospital attendant in the play *Harvey*. The play was sold out on Broadway, and Akronites who saw the show were delighted with many references to Akron in it. White would later play the same role in the 1950 movie *Harvey* alongside a frequent visitor to Akron, Jimmy Stewart. White is also well known as the Maytag repairman, starring in commercials for over twenty years.

In 1944, Lester Cowan had the opportunity of a lifetime, producing *The Story of G.I. Joe*, based on Ernie Pyle's book *This Is Your Infantry*. Released in 1945, *The Story of G.I. Joe* starred Cleveland native Burgess Meredith as Pyle and also featured Robert Mitchum. Besides playing Ernie Pyle, one of Meredith's greatest roles came thirty years later as Rocky's manager Mickey in the 1976 Best Picture *Rocky*, which landed him a much deserved Oscar nomination for Best Supporting Actor. According to General Eisenhower, *The Story of G.I. Joe* was the best war film yet, and it was nominated for four Oscars. Cowan's wife, Ann Ronnel, was nominated for two Oscars, including for Best Song; Robert Mitchum was nominated for his only Oscar, for Best Supporting Actor; and the movie was nominated for Best Screenplay.

Beacon Journal theater editor Betty French attended the premiere in Indianapolis, riding in the parade along with Pyle's dad and aunt in July 1945. In her review of the movie on July 8, 1945, French wrote, "Cowan, former Akronite and former *Beacon Journal* street circulation manager, has made Pyle's dispatches come to life magnificently on the screen. He uses many incidents which you will remember from Ernie's column in the *Beacon Journal*, tells them powerfully and realistically, but simply as Pyle told them."

Ernie Pyle couldn't stay away from the war long and headed out to the Pacific just in time for the bloodiest battles in that theater. Okinawa, the deadliest battle of the Pacific war, claimed his life on April 18, 1945. Thirty-nine Akron men also met death on the island alongside Ernie. Goodyear

Ernie Pyle *(left)*, Akronite Lester Cowan *(center)* and Burgess Meredith *(right)* talk over material for *The Story of G.I. Joe. Lester Cowan Collection, Harry Ransom Center, the University of Texas at Austin.*

Aircraft made a Corsair in honor of Ernie Pyle after he was killed and sent it to the Pacific. The Corsair had Ernie's picture on it as well as some messages.

The April 20, 1945 *Beacon Journal* editorial page read:

> *Millions of Americans experienced a shock, then a deep feeling of personal loss when they read that Ernie Pyle, the foxhole reporter and the doughboy's columnist, had been killed in the Pacific. They loved Ernie. He told the ordinary people at home about the ordinary soldier and sailor—what they did, what they talked about, how they felt…how they lived…and…how they died. To the G.I.'s, Ernie Pyle was tops. If this is the way it had to be, if this is the way the Great Designer planned it, we feel that Ernie is satisfied. He is with his boys.*

THE DEADLIEST YEAR:
JUNE 1944–MAY 1945

By the end of 1943, war had claimed 316 Akron men and 1 woman. The casualties had been relatively light, and after President Roosevelt met with Stalin and Churchill at year's end, newspaper reports across the country talked about a peace agreement being reached in Europe. In keeping with the national mood, the *Beacon Journal* headline on November 28, 1943, read, "World Awaits 'Big News Break' European Peace Talks Grow." There was even speculation early in 1944 that the war might end before the year was finished. Sadly, an early peace was not to be had. Instead, the Akron area and cities and towns across America were left devastated. By time it was all over, there would be well over 1,500 Akron-area deaths. Increased fighting in Italy in early 1944 and the invasion of Europe opened up the floodgates of death. Over 100 eighteen- and nineteen-year-olds from the Boy Scout Draft perished along with 192 Akron-area fathers. Akron had its first set of brothers killed in action in July 1944, and by war's end, fifteen Akron-area families had lost more than one son.

In 1944, war killed 741 Akron area men. Many argue that was the bloodiest year of the war, since 490 men died from the Akron area in 1945. That is a mistake, however, because 972 Akron area men died between June 1, 1944, and May 31, 1945—this was the deadliest year. May 1945, with 51 Akron deaths, edged out May 1944 with 49. January 1944 saw 33 deaths, February 38, March 26 and April 23. July 1943 saw 29 Akron-area men killed, and the deadliest month of 1943 was November with 36 deaths. The start of 1944 did not bring a significant increase in the number of deaths. However,

—WB BROWN.

War casualties hit Akron. Between September 1, 1944, and May 31, 1945, there were 721 Akronites killed. *Reprinted with permission of the Akron Beacon Journal and Ohio.com.*

beginning with D-day and the bloody fighting in the summer of 1944, the death toll began increasing. In September 1944, a war-weary Ernie Pyle reported he was returning home. Many Americans believed at the time that a German surrender was close at hand. After all, the Germans themselves tried to kill Hitler in July 1944. Between September 1, 1944, and May 31, 1945, close to fifty percent of all Akron-area deaths in the entire war occurred when 721 Akronites were killed all over the world.

The deadliest months of World War II for the Akron area were December 1944 (104 dead), July 1944 (100), April 1945 (97), March 1945 (88), June 1944 (84), February 1945 (83), November 1944 (81), January 1945 (80), October 1944 (69), September 1944 (67), August 1944 (67) and May 1945 (51)—all within a twelve-month period from June 1944 to May 1945. The thirteenth deadliest month was May 1944 with 49.

The deadliest days for the Akron area were February 19, 1945 (twelve dead), November 25, 1944 (eleven), June 6, 1944 (ten), December 18, 1944 (ten), December 7, 1941 (nine), January 21, 1945 (eight) and March 18, 1945 (eight). There were plenty of days when between five and seven Akron-area men were killed. The averages even in the bloody months of July and December 1944 were just over three per day, so any day where four or more were killed should be considered one of the deadliest days of the war for the area. Early in the war, most days with over three deaths were because of Akronites killed on the same ship. February 19 is unique not only as the bloodiest day of the war but also for the fact that all the Akron-area deaths that day were in the Pacific—eight on the first day of fighting on Iwo Jima, one at sea, two in Manila, and one on Luzon. All of the deaths on June 6, 1944, occurred in the D-day invasion. November 25, 1944, saw deaths

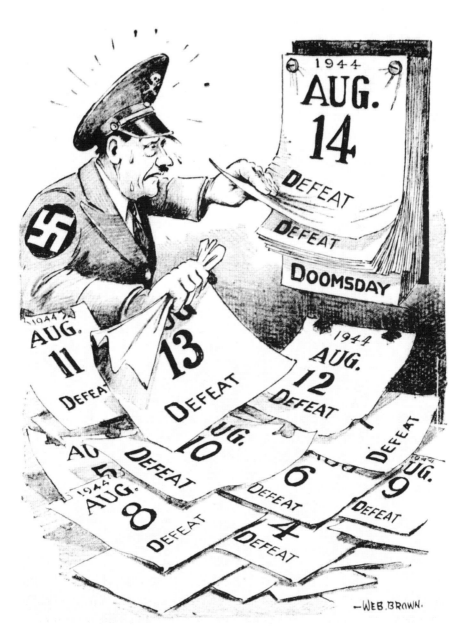

The war is not going well for Hitler in August 1944, but the bloodiest days of the war are still ahead. *Reprinted with permission of the* Akron Beacon Journal *and Ohio.com.*

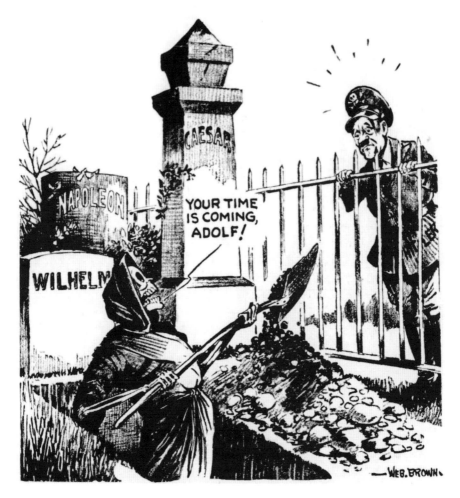

Kaiser Wilhelm dies and Web Brown and the Grim Reaper give Hitler a preview of his fate. *Reprinted with permission of the* Akron Beacon Journal *and Ohio.com.*

in both Europe and the Pacific, while December 18, 1944, combined the deadly German winter offensive with a typhoon in the Pacific that killed five Akronites. Casualty lists were similar all across the United States. The same days and months that were the deadliest for Akron were also the deadliest for Boston, New York, Detroit and Los Angeles.

It is easy to see why President Truman decided to drop the nuclear bombs on Japan. The casualties from June 1944 on were extreme leading all the way into the summer of 1945. America was running out of soldiers and workers.

Victory is near, but April 1945 sees ninety-seven Akronites killed in action, the third deadliest month of the war. *Reprinted with permission of the* Akron Beacon Journal *and Ohio.com.*

It had already been drafting fathers since 1943 and eighteen-year-olds since 1942. After the deadly German offensive was over, casualties continued to mount as the Allies pushed on to Berlin. Meanwhile some of the bloodiest fighting in the Pacific occurred to deliver even more death to the Akron area. Congress debated a work or fight bill to force workers to increase defense production and also debated drafting nurses to deal with this significant increase in casualties. Akronites and Americans were opposed to the work or fight bill, and it didn't seem to have much of a chance of passing. Struggling with industrial output and with such a high casualty rate, President Truman chose to drop the bombs. This was welcome news to many men stationed in the Pacific who had been overseas for two or three years and had no idea when they would return home. They expected an invasion of Japan would be long and bloody—the Battles of Okinawa, Iwo Jima and the Philippines all helped convince them of that.

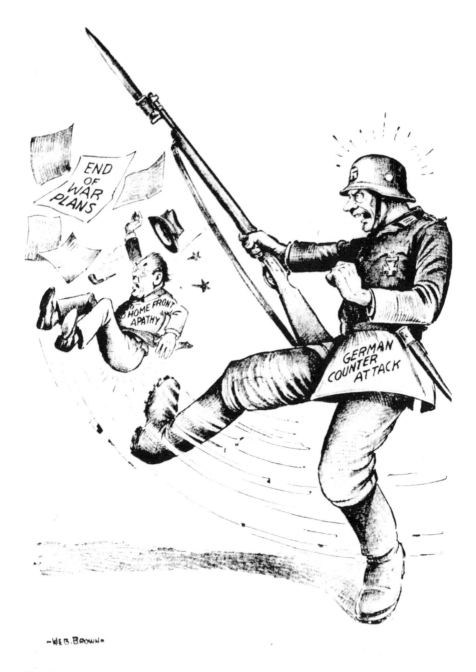

The Germans launch a counterattack that contributes to the 104 Akron men killed in December 1944. *Reprinted with permission of the* Akron Beacon Journal *and Ohio.com.*

AKRONITES LOSE THEIR ONLY SON

At least 254 Akron families lost their only sons during World War II.

Among them was a descendant of George Jacob Frank, who left Germany and settled near Uniontown, Ohio, in 1837 and whose family became prominent Akronites. The city was growing rapidly at the end of the nineteenth century. A population of over 40,000 in 1900 was headed up to 208,000 by 1920. Still, at the turn of the century, Akron only had a small library housed in rented rooms. Mary Edgerton was the longtime Akron librarian. Her father owned a beautiful house at 235 Edgerton Road—the road was named for him of course. She came up with the idea to contact Andrew Carnegie to see if the business tycoon and philanthropist would donate the money for a library. Carnegie had already built $15 million worth of libraries throughout the world. John Christian Frank, the president of the library board, was put in charge of the project, and Carnegie agreed to donate $70,000 to build a library in 1901. The people of Akron quickly realized that $70,000 was only enough for a simple brick building, when they desired something more elegant. They dispatched John Frank to New York to ask for more money. Carnegie donated another $12,000 to erect the stone building that sits at 69 East Market Street and is in the National Register of Historic Places. The Carnegie library was completed in 1904 by Frank Weary. Weary had left Akron in 1863 as a middle school–aged boy to become a drummer in the Union army; he marched through seven Southern states on General Sherman's march to the sea. Other Akron landmarks built by Weary include Buchtel Hall on the University of Akron campus; the Gothic Building; and the bell tower, memorial chapel and caretaker house in Glendale Cemetery. In September 1907, John W. Frank offered to open a road through his farm just north of the railroad tracks once he removed his potatoes. The Akron and Medina Road (present-day Route 18/West Market Street) was closed as state officials attempted to put down a test strip of concrete, and frustrated residents couldn't travel the popular route for months. Frank's donated road created a detour to bypass the closed portion of the Akron and Medina Road, and Frank Boulevard still runs along the northern edge of the railroad tracks today.

Lieutenant John E. Frank of 215 Metz Avenue was another descendant of George Jacob Frank. John's father, Charles W. Frank, had been killed in 1940 along with forty-two others when a freight train struck their passenger train head on. John E. Frank went into France a week after D-day and was wounded on August 15, 1944. He died of his wounds two days later. Voted

most likely to succeed in his West High School class, John Frank died in France at twenty-three. Widow Helen Frank lost her only son.

My grandfather John Carroll wrote hundreds of letters to my grandmother Betty Carroll during World War II that she saved. Among this collection is one letter written by Betty to her cousin John E. Frank. The letter was marked "deceased," because by the time it arrived in France, John had been killed in action. It was common for letters and packages to be sent back to family members when their loved one was killed in action. Occasionally those returned letters would deliver the crushing blow, as the letters sometimes arrived before the families received the official telegram from the War Department.

Dated July 5, 1944, this letter sat in an envelope unopened for almost seventy years:

Dear John,

You're a hard man to keep up with these days, so I thought I'd write real quick before you move again, altho it looks like your next move will be Berlin.

We were all pretty concerned when we heard you were in France, John, so take good care of yourself. I suppose that's kind of a foolish bit of advice, but you know what I mean…don't take any chances you don't have to.

I feel a little guilty writing about my nice vacation while you're sleeping in a fox hole, but that is about all I have to write about.

You'll have some interesting things to tell now, John, which probably aren't too pleasant, but hope you can soon look back at them. Your mother is fine and doing a good job of keeping her chin up. She always looks so pretty and dresses so nicely, that I think that keeps her morale up.

Johnny [my grandfather] *is still at A.P.O. 923, and hears nothing on the rotation plan, but the duration is soon enough for me.* [My grandfather had been overseas for over two years with no sign of rotating home.]

I know you're busy, so don't worry about answering this. Mother and Aunt Helen are as proud of you as the dickens, so for gosh sakes be careful!

Love,
Bet

John E. Frank was sadly just one of many only sons lost in the struggle. As the war dragged on, the *Beacon Journal* started publishing a section called "Taps" every Sunday listing the names of area men killed that week. Occasionally the *Beacon Journal* felt the need to add something at the beginning of the section, and on March 11, 1945, it led off with this emotional quote about Walter Innes: "New signals have been called for First Lieut. Walter Innes, 396 W. Wilbeth Rd., former Kenmore High School teacher and basketball coach, who has been declared killed in action in France after having been reported missing months ago."

Lieutenant Walter J. Innes was the only son of James and Margaret Innes and a 1926 graduate of Kenmore High School, where the former honor student taught civics and history for ten years. He was a star basketball player at Kenmore and Heidelberg College, where he was team captain his senior year, and he took over Kenmore's basketball program from his old coach Clair Ledger. Innes coached at Kenmore for eight seasons, with a regional appearance in 1942. He was drafted in July 1942. He went overseas in July 1944 and was first reported as wounded in action on October 24, 1944, in France. In February 1945, the government sent Walter's parents another telegram informing them that a mistake had been made and Walter was missing in action since September 20, 1944. Walter's last letter home was written on September 19, 1944, and his parents hadn't heard from him since. In March 1945, they got the dreaded telegram reporting that Walter was killed in France on September 20, 1944. He was thirty-five. Walter J. Innes Junior High School in Kenmore was dedicated to him in 1960.

Private First Class Charles "Bill" Brickles was a star athlete at Kenmore High School, lettering in baseball, basketball and football. He went overseas in March 1944, participating in the invasion of Guam before he was killed at twenty-two on January 15, 1945, on Leyte. Charles was reported killed in action the same day his basketball coach, Walter Innes, was listed as missing in action. Charles left behind his fiancée, Pearl Buck. After losing his only son, Charles's grieving father, William, commented on the irony of his two years of overseas service in World War I, saying it was supposed "to make the world safe for my son."

Staff Sergeant Kenneth C. Brown was the only child of Elizabeth Brown, a widow. In 1913, young Kenneth wrote Santa: "Dear Santa Claus—I would like a football, a drum, a baby sister, a raincoat, a hat, boots, desk, a chair, and a steam roller." Kenneth grew up, married Anna in 1931 and worked at Goodyear for sixteen years before the war. He was killed in France on July 29, 1944, at thirty-six.

Seaman First Class Harry Clark Widmeyer was listed as missing in action after the destroyer USS *Houston* was sunk in the Battle of the Java Sea in March 1942. On December 20, 1943, the Widmeyers received an undated card from their son written from a Japanese prisoner of war camp that said he was in good health and among friends. Harry's parents were overcome with Christmas joy and excitement—the last letter they had received from their son was in February 1942. Lillian Widmeyer was set to receive a wristwatch in August 1944 for twenty years of service with Firestone Tire & Rubber Company, but she requested a man's watch to give to Harry when he came home from the Japanese prison camp. In August 1945, the War Department announced that three hundred men from the USS *Houston* had been freed from a Japanese prison camp, and Lillian waited anxiously for news about Harry. She was at work at Firestone when she got a call from her mother that a telegram had arrived. Eager to know its contents and hoping for good news, Lillian asked her mother to read it to her over the phone. The telegram said that Harry had died in the Japanese prison camp in Burma on August 15, 1943, at twenty-two.

Private First Class Maurice Lawson was the only son of Edina Lawson, a widow. Maurice was the first Akron-area soldier reported killed during the D-say invasion. He was killed on Utah Beach on June 7, 1944, at thirty. Maurice's mother was heartbroken; she said, "He is all I have lived for. If he is dead then I do not want to go on. I pray there has been a mistake made." This was Maurice's first experience in combat, and in his last letter home, he said, "I have talked to several boys who have seen action and they said they were plenty scared."

Private First Class Richard C. Layton was a North High grad drafted into the army on May 8, 1943. He had his wife, Diana, sell their car to put a down payment on a house at 1493 Indianola Avenue. She wrote him, "We'll have a lot of fun here, honey, when this old war is over." Diane's husband was excited to come home, but before he could, he was killed in the battle for Saint-Lô, France, on July 20, 1944, at twenty-two. He was the only son of Grace Layton.

Fifteen Families Lose Two Sons in the Last Year of the War

Joseph Handler was a Yugoslavian immigrant who came to the United States in 1909 and to Akron in 1912. Joe's son Alfred Handler was overseas

ten months when he was killed in the Battle of Maffin Bay in New Guinea on June 23, 1944, at twenty-six, leaving behind a young wife, Rebecca. On Sunday, August 5, 1944, Joe Handler and his wife, Lena, answered their door at 557 Rhodes Avenue to receive another envelope filled with bad news. The Handlers now read that Private First Class Louis Handler was killed in France on July 8, 1944, at twenty-three. The Handlers were the first brothers killed in the Akron area. In Louis's last letter from Normandy, he wrote how God would help him get home to see his baby. Louis and Isabelle Brunstein married in October 1943, while he was on leave from Fort Breckenridge, Kentucky. They were expecting their child, Lewis Michael, in September 1944. Louis was a 1939 graduate of West High School who was drafted on November 21, 1942. Twenty-one-year-old Harry Handler was drafted on April 3, 1943, and was also fighting in New Guinea. The Handlers contacted Washington hoping to bring their third son home. Harry was devastated when he learned that Alfred had been killed after a letter he sent to Alfred was returned marked "deceased." Harry's parents were fearful he would learn of Louis's death the same way while he was still in combat. Harry was also receiving the *Beacon Journal* overseas, and his parents were hoping he wouldn't find out that both of his brothers were dead through the paper. Harry Handler made it home, but he was not released early, since the Handlers had another son who was not in service.

In June 1945, the Alspach family learned that their son Sergeant Corwin Alspach, who had been missing in action since June 5, 1944, was declared killed at twenty-two on a mission over France. Three days later, another telegram came informing them that Private Thomas Alspach, who was missing in action, had been declared killed at nineteen on March 26, 1945, in Germany.

Staff Sergeant Anthony Biondo was a radioman on a C-47 transport plane killed on September 17, 1944, on a mission over Holland. Anthony's brother Private First Class Angelo Biondo enlisted after Anthony was killed. He was killed at nineteen on May 22, 1945, on Okinawa.

Machinist Mate First Class Chester W. Clotfelter was a 1937 West High School grad who joined the navy in June 1941 and survived the attack on Pearl Harbor when he was stationed on the USS *Pennsylvania*. He was married and had two daughters ages one and two. The telegram came just before his twenty-fourth birthday announcing he had been killed in action on July 17, 1943, on his battleship in the Pacific. It was Chester's brother Seaman First Class Clifton B. Clotfelter who received the telegram telling of Chester's death. He did his best to soften the blow for his mother, who had a fractured

spine and had not walked in four years. Clifton always told his mother that she would walk again, and her loving son reminded her of that in his last letter to her. Clifton was drafted later that year in December. He was killed just after his twenty-fourth birthday on October 26, 1944, when a torpedo struck his LST landing boat during the Battle of Leyte in the Philippines. Mae Clotfelter lost two sons during World War II as she struggled with her own health issues. Her family published this tribute in the *Beacon Journal* after her death in the 1950s.

In Loving Memory of Our Dear Mother Birdie May Clotfelter

Who passed away one year ago, May 31, 1955. Sadly missed each day with her sweet smile and her words she would say. "Longing for that day when I will say goodnight here and good morning up there. Where there will be no pain or sorrow" And that she would meet her two dear boys who gave their lives to their country.
CHESTER CLOTFELTER
July 17, 1943
CLIFTON CLOTFELTER
October 26, 1944
SADLY MISSED BY THE CLOTFELTER FAMILY

"Barberton Has Lost Its First Pair of Brothers in This War" read the November 18, 1944 *Beacon Journal* headline. Sergeant Charles A. Brucker and Staff Sergeant Harold Brucker died within days of each other, Charles on September 28, 1944, on a mission over Southern France as a radio gunner on a bomber. Harold, a paratrooper, had died five days earlier.

First Lieutenant Walter F. Griffin was a West High School graduate who won an appointment to the U.S. Military Academy at West Point on July 1, 1938. He was killed in the American theater on March 10, 1943, in a bomber crash near Del Rio, Texas. Walter's father, George, died on June 16, 1944. After retiring from B.F. Goodrich, George ran a parking lot behind the *Beacon Journal*. The paper reported, "The *Beacon Journal* employees who saw him daily noted that he had failed in health since his son, Lieut. Walter Griffin, was killed in an airplane crash in Texas. They knew he was worried too about another son, Lieut. Charles Griffin who is overseas." After his father's death, tragedy struck the family again, as Lieutenant Charles Griffin, who held the Distinguished Flying Cross and the Air Medal with two oak leaf clusters, died at twenty-two on December 10, 1944, when his plane

crashed one hundred miles northeast of Myitkyina, Burma. All four men on board the C-47 cargo plane were killed, and their bodies were brought back for burial in 1947. His mother, Melissa, said, "I tried to persuade Charles to enter the ground crew rather than be a pilot after his brother was killed. He said 'mother, unless you absolutely forbid it, I want to fly, too.' " Charles was missing in action until 1946, when Melissa was notified of his death. "I had tried to hold out hope that my one boy would return, but underneath I felt he was gone," she said. Melissa Griffin lost both of her sons in the war.

Private First Class Edgar J. Hamric of 404 Bell Street was a milkman before the war. The father of five was drafted and sent overseas in March 1943 to fight in North Africa and Italy. In 1944, he was sent into Southern France, where he was killed on September 20, 1944, at thirty-one. He left behind his wife, Lourdene, and children, Louise, fourteen; Ida Mae, thirteen; James, eleven; Glenda, nine; and Dennis, four. On May 15, 1979, the friends and family of Corporal Richard Leroy Hamric gathered at Greenlawn Cemetery, where "Taps" sounded for the tail gunner, who was killed when his B-24 Liberator crashed in the New Guinea jungle on February 28, 1945. Leroy volunteered to go on the bombing mission and had been overseas for only twelve days when he was killed at twenty-three. Like his brother Edgar, he was drafted into the service. In the fall of 1978, two Australian ranchers flying over New Guinea noticed the tail of a plane sticking up out of the jungle. Leroy Hamric's Liberator, with eleven crew members, had never been located after it went missing during a storm. Over three decades later, the U.S. Army was notified of the plane's location by the Australians, and soldiers hacked their way through the New Guinea jungle to discover the remains of eight crew members, including Leroy. The army men also ran into an old native who said he witnessed the plane crash and made his way to the wreckage. He said he saw footprints and a trail of blood leading into the jungle away from the plane. The army believed that three of the crew members survived the crash and tried to make their way through the jungle; their bodies must be in there somewhere. Glenn Moyers, who grew up in South Akron with Leroy Hamric and his wife, Annie, took part in the search when his plane disappeared in 1945. He said, "We flew up and down those mountains for three days, but we couldn't find a trace. Nothing. But that jungle in New Guinea—you could hide the Empire State Building in there and never find it." Thirty-four years after his plane disappeared, Leroy's body landed at Cleveland Hopkins Airport. His son David was now thirty-five. Glenn Moyers married Leroy's widow in 1946. Annie had always wondered if Leroy would turn up. She said, "Even though we were all pretty

sure Leroy was dead, you always fantasize when you don't know for sure. Sometimes I'd think maybe he hit his head in the crash and had amnesia and was living on an island somewhere. I never knew for sure whether he might not just walk in the door someday. Now it's over at last." The Hamric brothers' deaths struck a double blow to their mother, who published this in the *Beacon Journal* on Memorial Day, 1953:

> *In Loving Memory of My Sons*
> *Edgar J. Hamric*
> *Who passed away Sept. 20 1944 and*
> *Richard Leroy Hamric*
> *Who joined him Feb. 28 1945*
> *Gone but not forgotten*
> *By Their Mother,*
> *Elsie Hamric*

"Corporal Neidlinger is the second and last son of Claude C. Neidlinger to die in action in this war," reported the *Beacon Journal*. Sergeant George Robert Neidlinger was killed in Sicily on August 9, 1943, at twenty-four. Corporal Gates Neidlinger was killed on February 10, 1945, on Luzon.

Private First Class Michael Szucs of Barberton was killed in France on January 25, 1945, at twenty-three. Julia Szucs, a Yugoslavian immigrant, later lost another son, John J. Szucs, who served in France and died at twenty-one on April 30, 1946, at a veterans hospital.

Tech Sergeant William Vodlick of Barberton enjoyed a happy reunion with his brother Corporal John Vodlick Jr. in North Africa. They both fought at Salerno and later at Anzio. William was killed in Italy on June 14, 1944, at twenty-four. John tracked down William's grave and talked to some of the men he served with to find out what happened. He told his parents he would tell them all about it once he got home. John's fighting was not done, however. He was killed in France on January 30, 1945, at twenty-seven.

Marine private first class Richard C. Brown was the son of World War I marine Archie Brown. On March 7, 1945, Richard's parents woke up early on a dark, rainy morning. They heard Richard yelling upstairs to them, and both parents yelled with excitement and headed downstairs. Richard wasn't there, but the parents were sure they heard his voice. Baffled, they went back to bed. Richard's fifteen-year-old dog Blackie died later that day, and the Browns felt something was wrong. In April 1945, Richard's parents were told that he was killed on March 7, 1945, on Iwo Jima at nineteen. The

stunned and grieving parents could only think back to that strange morning when they were sure they heard their boy calling them from downstairs. In June 1945, the Brown family was notified that another son, Private David M. Brown, twenty-two years old and the father of five-year-old David Jr., was killed on Okinawa on April 23, 1945. Archie Brown and his wife visited the Red Cross hoping they could help their son Douglas return to the states. "We don't want Douglas completely removed from service for he would never consent to that, but we do wish he could be stationed in this country."

Private First Class Robert Gurich of Barberton fought through North Africa, then Sicily, and was later shifted to France, where he was killed on August 8, 1944, at twenty-eight. Private Nick Gurich was killed on December 28, 1944, at twenty-nine in Belgium during the Battle of the Bulge.

Private Bruce K. Beals was drafted on December 2, 1943, as part of the Boy Scout Draft. He was killed in France on July 25, 1944, at eighteen. Upon learning on her son's death, Bruce's mom said, "He was so young to go. He was only eighteen. Why he wouldn't have been in the army a year until next December. He was sent right overseas and into action." Bruce's brother Sergeant James Beals Jr. was never told of his brother's death, and since he was serving in France too, he scanned trucks headed to the front for his little brother every day. Bruce's parents didn't want to tell him his brother was dead while he was still in combat. James was killed in France on October 9, 1944, at twenty-two. James left behind his wife, Julia, and a fifteen-month-old son. The *Beacon Journal* reported, "Sergt. James Beals is reunited with his kid brother at last. The Akron boys were joined in death in that place of peace where tired soldiers go—where there is no more battling and bloodshed." In 1948, Jack Beals was fatally injured in an automobile accident and later died after 113 days in the hospital at twenty-four. In July 1952, twenty-year-old Donald Beals was drafted, and by December, his mom learned he was headed to Korea. She said, "I don't think I can stand losing another one. I wouldn't mind his being in service the next two years if they would keep him on this side. I've appealed to Rep. [William] Ayres to try to keep Donald on this side of the ocean. I don't have too much hope. You see, he isn't my sole surviving son, I still have Max."

Staff Sergeant Rocco DePalo, with the Forty-Fifth Infantry Division, was killed in France on November 7, 1944, at twenty-eight. In early 1944, Rocco fought on the Anzio beachhead in Italy, where he was wounded by shrapnel. After recovering from his wounds, Rocco was sent to France. He received two Purple Hearts. He also received a Bronze Star for carrying a friend to the medical tent under heavy enemy fire. Rocco was a South High

School graduate who worked for B.F. Goodrich before the war. His only sibling, twenty-five-year-old Angelo, died on June 28, 1944, at Brecksville Veterans Hospital after being sent home on July 2, 1943, from an accident that fractured his spine at Camp Robertson in California. Vito DePalo and his wife, Margaret, lost both their sons to the war.

Sergeant Robert E. Hill of Greentown was overseas a year and a half. He was killed on Okinawa on May 11, 1945, at twenty-six. Robert's brother Donald Hill was drafted in the summer of 1944 and was killed in the American theater in a Tennessee train derailment along with eleven area men, including four from Akron. Donald left behind two daughters, Carol Ann and Jeanette Louin, and his wife, Evelyn.

V-E, V-J DAY AND AFTER
WORLD WAR II

Tuesday, May 8, 1945, was President Truman's sixty-first birthday, and he had moved into the White House only the day before. It was no ordinary birthday, as the man who took over for President Roosevelt after his death on April 12, 1945, was about to announce the unconditional surrender of Germany. Akron, like most cities, was ready to celebrate, but Truman asked Americans to make it a quiet one and continue to work toward total victory. White paper streamed down from B.F. Goodrich as workers poured out and celebrated the end of the war in Europe. All over town, workers went home at noon or streamed out of work to celebrate after the announcement. Still, those at both Firestone and Goodyear Tire & Rubber Companies mostly stayed on the job. The midnight curfew was lifted, as was the brownout, which restricted unnecessary lights downtown. Even though the downtown theaters and restaurants were lit up, the streets of Akron were mostly deserted. Akronites took Truman's advice and celebrated quietly in their homes. The war with Japan was still raging, with bloody fighting on Iwo Jima, Okinawa and in the Philippines. Newspapers and radios were already reporting that millions of American men might be shifted from Europe to the Pacific theater. Most Akron families had relatives in the service, and with the war not over yet, V-E Day turned into a day of prayer. That Tuesday was likely the largest crowd Akron-area churches ever saw on a weekday. Akron's first V-E Day baby, Dwight Homer Parlin, was born at 3:30 a.m. and named Dwight for General Eisenhower, whom his father was serving under in Europe.

On May 11, 1945, it was announced that the first soldiers released from the army would be a group of 2,500 men. These men would be released based on the point system and needed at least eighty-five points to be considered. Eighteen Akron men were released on May 15, 1945, and were the first to come home, saying they reported for duty after a 45-day furlough and were expecting to be sent back overseas when the army informed them they were being discharged instead. The military also announced that men who had served four or five years would start to be released in the summer of 1945. The pre–Pearl Harbor draftees, some of the longest-serving soldiers of World War II, would finally come home. My grandfather, who signed his first letter "364 more days," was set to be released after over four years of service.

In San Francisco, the United Nations Charter was created at a conference of world leaders in June 1945, and America dreamed of a peaceful world even while it was still at war. Post–World War II recovery and peace would be up to this body. Managing the use and development of the new atomic bomb would also fall to this group. Announcements that American B-29s in November 1945 had successfully completed nonstop flights from Japan to Washington, D.C., showed that bombers could now reach America from anywhere in the world. The B-29s were already being overshadowed by Hap Arnold's announcement in August 1945 that America had developed rockets capable of firing remotely and seeking the targets on their own without pilots.

On Tuesday, August 14, 1945, at 7:00 p.m., President Truman announced the Japanese surrender, and Akron got ready to party. The first babies born following the announcement were fittingly Victor Michael Rogers, born at 7:10 p.m., and Victoria Pohl, born at 8:03, the first Akron babies to breathe the peacetime air. The celebration marking the end of the war was understandably not as subdued as the celebration of victory in Europe. Cars and people flooded into downtown. Fireman Harry Bell kicked off the festivities by setting off the air raid siren. Paper rained down from everywhere as Akronites waved flags and held up papers showing the headline of the Japanese surrender. People came from everywhere and shut down the streets of downtown Akron before the police could implement their plan to clear Main Street from Market to Exchange Streets. Instead, Main Street was packed with cars, trolleys, people and even a tractor. According to the *Beacon Journal*, "Auto horns, factory whistles, sirens, tin pans and pots, home made bombs, and illicit firecrackers set up an ear-splitting inferno of sound." The people of Akron "danced, paraded, and yelled themselves hoarse.

Pretty girls kissed perfect strangers." A reporter talked with a woman who said, crying, "Why are they celebrating? I had three brothers in it, two of them were killed last month." Police, who had long given up on getting the celebrants on the sidewalks, looked on as servicemen had a ball directing traffic when they weren't receiving handshakes, hugs and kisses from girls in the crowd. The rowdy crowd enjoyed bonfires in the streets as it lit piles of papers on fire, and some say the party would have gone on all night if it weren't for the rain. The *Beacon Journal* continued: "The rains started coming down in barrels—not buckets. Almost as miraculously as it appeared, the crowd vanished."

The *Beacon Journal* announced, "Today, as we celebrate the end of a war we didn't want, we are all determined not to let war happen again." The *Beacon Journal* emphasized that people must work just as hard at peace as they did at war, and then "there will be no more war." The VFW put up a huge sign on Arlington Road that read, "Peace is won work to maintain it."

Despite the jubilation, war opened fresh wounds as reports of Akron men killed on their way back from delivering parts for the nuclear bomb on the cruiser *Indianapolis* surfaced. Over 800 men were killed in the sinking of *Indianapolis*; many died in the days after the ship was sunk in shark-infested waters. Additionally, Robert Morris was killed at nineteen in Germany in November 1944. Robert's mom informed a reporter that his dog, who was always waiting at the window for the boy who would never return, was killed on V-J Day. The dog was a victim of a random celebratory bullet that accidentally hit him in the front yard of the home. In between the celebrations was the constant reminder of death and sadness brought to the Akron area by the loss of over 1,500 Akronites during the war.

Death was not the only blow for the city. Goodyear Aircraft announced it would cut fifteen thousand of its eighteen thousand remaining jobs as the war ended, and the end of the war brought the cancellation of $45 million in war contracts for the Akron area. Akronites quickly shifted from making military tires to making tires for civilians, who were more than hungry for them after years of rationing both gasoline and tires. As the rubber industry often put it, "rubber is flexible and so are we." It wouldn't take long to go back to peacetime production.

There would be a loss of jobs, but many pointed out it would mostly affect women in the factories, who were working more as a patriotic duty, and high school–aged kids, who many said should return to school. "Rosie the Riveter has rat-tat-tat-ed her last rivet at Goodyear Aircraft," the *Beacon Journal* stated. Many men would be leaving war work behind to

return to farm work or—as they called it—the less exciting jobs of teaching and bookkeeping. The men and women at Goodyear Aircraft were wished goodbye and good luck from a grateful nation.

Ten million homes would be built in the United States in the next decade to address the desperate need for housing and would launch the rapid suburbanization of cities across America, including Akron. War housing projects would now turn from housing war workers to housing returning war veterans. Only one out of six Akron vets was able to find a place to stay as they started returning from war in the summer of 1945, leaving many men, their wives and kids living together with relatives.

On August 16, 1945, fans in Cleveland were excited to see Chief Specialist Bob Feller and his Great Lakes Bluejackets come to town to face off against the Crile General Hospital baseball team. Feller, managing and pitching for the Great Lakes team, was a no-show, as all planes were grounded for days following the announcement of Japan's surrender. But fans wouldn't have to wait long for his return: the navy announced on August 19, 1945, that Feller, who had been in the service for forty-nine months, twenty-eight of them overseas, was to be released. The Cleveland Indians celebrated Bob Feller Day on Friday, August 24, 1945, as "Rapid Robert" took the mound for the first time since September 26, 1941. Feller struck out twelve members of the league-leading Detroit Tigers to snap the Indians' five-game losing streak. He held the Tigers hitless after the third inning in the 4–2 victory.

Bob Feller may have been back, but certain superheroes were still fighting the enemy. Reports rolled in that comic strips and their characters were unprepared for the sudden end of the war brought on by the atomic bomb. Many of the characters were still fighting the enemy weeks after the Japanese surrender. Comic strip artists assured readers that they had a reconversion plan like the rest of the war industry and would be returning to more peaceful activities soon.

After World War II, world leaders and veterans said that if there was a World War III, the world wouldn't survive. This led to the major world powers fighting each other in proxy wars in smaller countries like Korea and Vietnam instead of taking each other head on. The United States shrugged off isolationism and joined the United Nations to try and keep World War III from occurring.

On September 2, 1945, the same day the Japanese signed the surrender, Ho Chi Minh declared Vietnamese independence. Vietnam, a French colony, had been fighting Japanese invaders with Allied support. Ho Chi

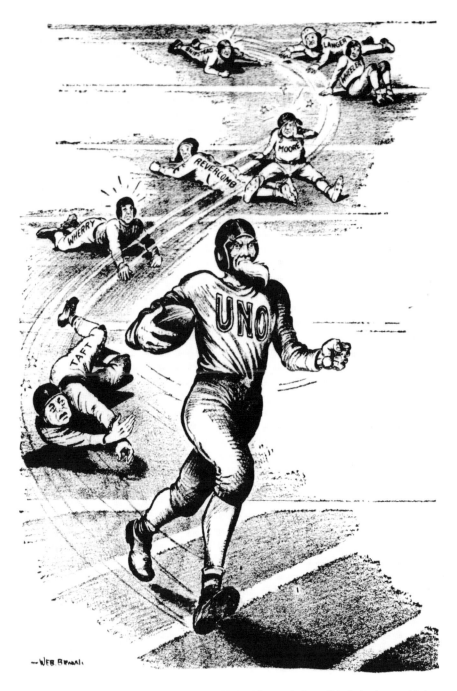

Uncle Sam breaks loose for a big day as the United States shakes off isolationism and joins the United Nations. *Reprinted with permission of the* Akron Beacon Journal *and Ohio.com.*

Minh quoted Thomas Jefferson, and as the French returned to his country, he sent two telegrams to Washington, D.C., asking for help. Those telegrams would be ignored. President Truman's administration opposed the French return to Vietnam but did little to stop them. Rebuilding Europe and making France a strong ally was his top concern. After America ignored him, Ho Chi Minh turned to the only place he could for weapons and support, the Soviet Union.

In 1949, China shocked the world when it fell to communism. After the Americans didn't intervene in China, Joseph Stalin gave the go-ahead for the communist North Korean troops he supplied and trained to invade and take over South Korea on June 25, 1950, leading to the Korean War.

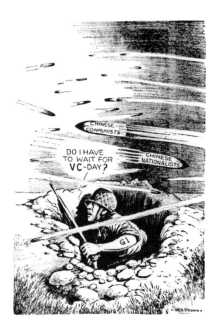

The war is over, but battles rage elsewhere immediately after the war ends. *Reprinted with permission of the* Akron Beacon Journal *and Ohio.com.*

In 1954, the French suffered a humiliating defeat at the Battle of Dien Bien Phu and promptly left Vietnam. Free elections were supposed to be held in the coming years, but the United States wouldn't allow it, believing that Ho Chi Minh, a communist now supported by the Soviet Union, would win. France, a country whose post–World War I selfishness helped cause World War II, should not have been allowed to return to Vietnam. Over 250 Akron men lost their lives in France during World War II, and for their sacrifice, America should have insisted France stay out of Vietnam.

"Every dad will gladly shoulder a gun now, if he can be sure that his son won't have to go to war in 1963," said *Beacon Journal* editor John S. Knight on August 4, 1943, as America began drafting fathers to fight in World War II. On Flag Day, June 14, 1945, the *Beacon Journal* headline read, "Must Our Boys Fight Again in 20 Years?" Six-year-old Freddy Martin is pictured in the article saluting the American flag, while eighteen-year-old marine private first class Bill Morgan is pictured kissing the flag from his wheelchair. Morgan was paralyzed from the waist down by a Japanese sniper on Guam. The *Beacon Journal* asked, "Are you working and praying

for a lasting peace—so that in 15 or 20 years Freddy won't stop an enemy bullet the way Bill did?" The peace that Americans wanted for future generations wasn't there. It would take the Vietnam generation to bring the draft that started in 1940 to an end.

On November 23, 1945, the *Beacon Journal* wrote an editorial titled "What Good Is a Job to a Homeless Vet." There was nowhere to live in Akron during the war, and the situation grew worse as the war ended and GIs began returning to Akron from all over the world. The only major cities in Summit County before the war besides Akron were Cuyahoga Falls and Barberton. All land that wasn't developed in Akron was being turned into new housing and schools. Firestone High School and the northwest side of town expanded rapidly, and the farmlands of Montrose were turned into shopping centers. Once-rural areas of Ellet, Stow, Hudson, Green, Macedonia, Copley and Twinsburg now boasted some of the area's largest high schools and communities thanks to the housing and baby boom that followed the war.

House-hunting veterans don't have many options, which will eventually lead to a housing boom. *Reprinted with permission of the* Akron Beacon Journal *and Ohio.com.*

In October 1947, the flags of the nation were flown at half-staff as over three thousand bodies arrived from overseas, including thirty-eight from Akron. Washington, D.C., flew flags at half-staff for the first time in history for someone other than a dead president. Through 1949, hundreds of Akronites had their sons returned from overseas cemeteries for burial at home. Some families chose to leave their loved ones buried in military cemeteries across the world.

The Soapbox Derby returned to Akron in 1946, and in 1947, actor and World War II veteran Jimmy Stewart made the first of many appearances. Stewart's first movie after coming home was *It's a Wonderful Life* in 1946, directed by Colonel Frank Capra. Stewart earned another Oscar nomination for his role as George Bailey. Another frequent guest of the Soapbox Derby after World War II was Akron's and Shorty Fulton's good friend Jimmy Doolittle. Future presidents Richard Nixon and Ronald Reagan also attended.

Actor Jimmy Stewart at the Soapbox Derby. *Reprinted with permission of the* Akron Beacon Journal *and Ohio.com.*

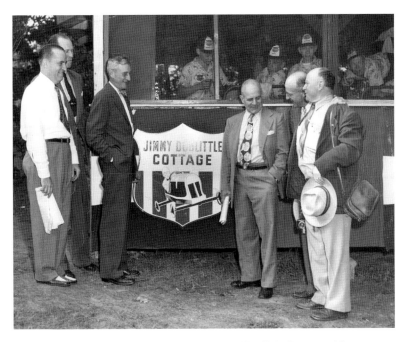

General Jimmy Doolittle stands in front of the Jimmy Doolittle Cottage with an unidentified man and Shorty Fulton with hat in hand at the Soapbox Derby. *Akron–Summit County Public Library, Shorty Fulton Collection.*

Ronald Reagan goes by the *Akron Beacon Journal* in 1951 during the Soapbox Derby parade. *Reprinted with permission of the* Akron Beacon Journal *and Ohio.com.*

Left: John S. Knight *(right)* speaks to President Kennedy *(left)* four days before his assassination. *John S. Knight Papers, Archival Services, the University of Akron, Akron, Ohio.*

Right: President Kennedy delivers an address four days before his assassination. *John S. Knight Papers, Archival Services, the University of Akron, Akron, Ohio.*

After the war, John S. Knight continued to grow his newspaper empire and influence. At one point, Knight Ridder, which he founded, had the largest newspaper circulation in the country with 3.6 million readers daily and 4.2 million on Sundays. John S. Knight seemed to know every important figure and be nearby at every important moment. In 1963, he attended a dinner in Miami with President Kennedy; four days later, President Kennedy was assassinated in Dallas.

In 1964, President Lyndon Johnson visited Akron and spoke at Memorial Hall, which was dedicated in 1954 to the memory of the 1,533 men and women from Summit County who died during World War II. President and Lady Bird Johnson stopped by the *Beacon Journal* to thank John S. Knight for his endorsement of Johnson over Republican candidate Barry Goldwater. Johnson would use a naval incident eerily similar to President Roosevelt's tactics in the Atlantic in 1941 in the Gulf of Tonkin. Claims of an attack on the USS *Maddox* by North Vietnamese vessels would spark the Vietnam War in 1965.

Vice President Richard Nixon came to town in August 1959 and had a ball leading the Soapbox Derby parade. Nixon, who became friends with

President Lyndon Johnson shows off the endorsement for the 1964 presidential election by the *Akron Beacon Journal* while Lady Bird Johnson and John S. Knight look on. *Reprinted with permission of the* Akron Beacon Journal *and Ohio.com.*

President Lyndon Johnson campaigns at Memorial Hall in 1964. *Reprinted with permission of the* Akron Beacon Journal *and Ohio.com.*

Richard Nixon works on his golf game at Portage Country Club. *Reprinted with permission of the* Akron Beacon Journal *and Ohio.com.*

Knight in the 1940s, first visited Akron in 1951, and his visits weren't always for political purposes. He spent time at John S. Knight's house and golfed at Portage Country Club. In 1968, Nixon campaigned for the presidency on ending the Vietnam War, but in the spring of 1970, he sparked protests across the country when he went on the offensive and invaded Cambodia. On May 4, 1970, four students were killed on Kent State's campus during a clash with the National Guard, which was sent in by Governor James Rhodes.

During Nixon's presidency, a government official leaked the Pentagon Papers to the *New York Times*, exposing the fact that the government prior to the Nixon presidency had lied to the American people about how things were going in Vietnam. Nixon, not at all happy about a leak in his government, created a covert group called the Plumbers to fix the leak. President Nixon's Plumbers expanded their activities and were arrested trying to bug Democratic National Headquarters in the Watergate building in 1972. John S. Knight would shock many *Beacon Journal* readers

This page: Vice President Richard Nixon at the Soapbox Derby in 1959. *Reprinted with permission of the* Akron Beacon Journal *and Ohio.com.*

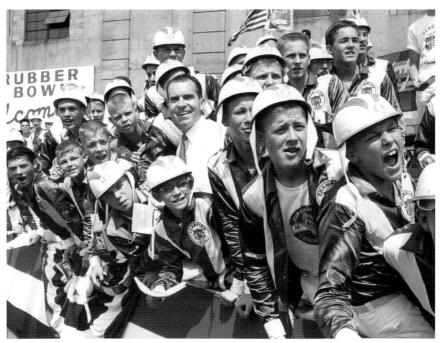

Richard Nixon *(left)* and his friend John S. Knight *(right)*. *Reprinted with permission of the* Akron Beacon Journal *and Ohio.com.*

by announcing that he would not vote for either presidential candidate in the 1972 election. He had lost faith in President Nixon, who would later resign the presidency to avoid impeachment, and did not care for George McGovern. The move sparked countless letters to the editor, and readers could not believe such a promoter of democracy as John S. Knight wasn't going to vote or endorse a presidential candidate.

INDEX

ABOUT THE AUTHOR

Born and raised in Akron, Ohio, Tim Carroll attended Case Elementary School, Litchfield Middle School and Firestone High School before obtaining a history degree from the University of Akron. Both his grandfathers, John M. Carroll and John F. Ward, were drafted before Pearl Harbor and served close to three years overseas in the Pacific.

Visit us at
www.historypress.com